IMAGES
of Rail

EASTERN KENTUCKY
RAILWAY

IMAGES
of Rail

EASTERN KENTUCKY
RAILWAY

Terry L. Baldridge

ARCADIA
PUBLISHING

Published by Arcadia Publishing
Charleston SC, Chicago IL, Portsmouth NH, San Francisco CA

Printed in the United States of America

Library of Congress Catalog Card Number: 2007924371

For all general information contact Arcadia Publishing at:
Telephone 843-853-2070
Fax 843-853-0044
E-mail sales@arcadiapublishing.com
For customer service and orders:
Toll-Free 1-888-313-2665

Visit us on the Internet at www.arcadiapublishing.com

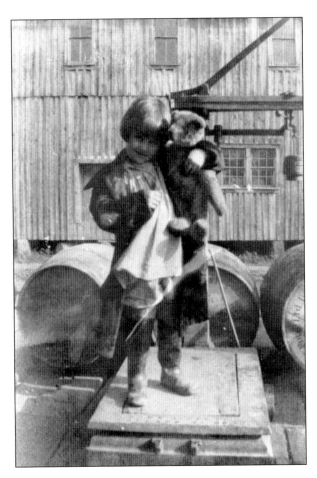

Little Helen Duncan, age four, poses with her bear atop the Webbville depot scales in the mid-1920s with barrels and the Eastern Kentucky Railway storehouse in the background. Her father, Fred Duncan, served as the Webbville agent for the Eastern Kentucky Railway and the Southern Eastern Kentucky Railway Companies for a couple of decades beginning in the early 1910s.

CONTENTS

ACKNOWLEDGMENTS

In 1974, my grandfather Alva Baldridge and H. O. Riggles introduced me to the railroad through stories and artifacts they shared. David Spencer recorded many stories regarding the Eastern Kentucky (EK) Railway in his newspaper articles "Another Time and Place." Without these three, this book would not be possible. I also appreciate stories of riding on the train from both my grandmothers, Janetta Baldridge and Evelyn Eastham. I am profoundly thankful to the host of older ones with whom I spoke over the last 33 years and who had a twinkle in their eye when relating stories of the EK Railway.

I would like to thank Kendra Allen and Arcadia Publishing for their kindness and the way they have guided me to this point.

I am deeply appreciative of the following for their contributions in the form of photographs and information: the Eastern Kentucky Railway Historical Society; Helen Duncan Dunkle; Ralph Dunkle; Bob Yoak; Jim McKee; Jim Allen; the Greenup County Library; the Minnie Crawford Winder Room at the Boyd County Library; Jim Powers; Marvin McHenry; Martin McHenry; the Denton Web site; the Carter County Genealogy Web site; Joel Carter; Don Mills; William Tandy Chenault; the Lawrence County Library; the Chesapeake and Ohio Historical Society; the Massachusetts Historical Society; WUGO Grayson; the Ashland Daily Independent; the Greenup News Times; the Kentucky Historical Society; the McConnell House in Wurtland, Kentucky; Gaines Johnson; tourgreenupcounty.com; the Hunnewell family; Kentucky Public Television; and Marshall University.

Finally, for their support every day, I would like to thank my father, Norman; my mother, Bonnie; my stepmother, Francis; my sister Kathy; my son Keenan; and my wife, Heather. Nothing would be possible without them and my friends at the Kingdom Hall.

INTRODUCTION

In the year 1865, two investors from Boston met to discuss various business ventures afar and within the Ohio River Valley. One idea was to invest in land and mineral rights along the Little Sandy River Valley in Greenup County, Kentucky, under the name Argillite Mining and Manufacturing Company. It was said that the land was rich in coal, iron, and timber. But neither of the two nor sub investors investigated the region to verify the claim. Two significant events transpired during 1865. First the company purchased 25,000 acres of land, which included a blast furnace at Argillite and the Greenup furnace several miles farther north; on December 14, 1865, the name of the company changed to Kentucky Improvement Company. Cast-iron property markers were placed throughout company-owned territory.

During the same year, Nathaniel Thayer, one of the investors in the Greenup project, funded an expedition to South America led by Prof. Louis Agassiz. The Thayer expedition was considered a great success because of the quantities of collected items brought back to Cambridge. Also making up the expedition was an adventurous young man who enjoyed photography. Walter Hunnewell, son of financier Horatio Hollis Hunnewell, was granted permission to accompany the expedition south and would not return until 1866. H. H. Hunnewell was the second investor in the Kentucky Improvement Company. Both Hunnewell and Thayer were very familiar with each other and had on several occasions come together to invest their money in railroads, science, and other ventures, even bringing court tennis to the United States from England.

It was apparent during the late 1860s that the quality of the coal and iron in the Little Sandy River Valley was well below average. Nevertheless, the furnaces used the coal and iron up and became the first in a long list of abandoned and sold Eastern Kentucky Railway properties.

In 1870, reorganization took place, and on February 28, the Kentucky Improvement Company deeded to the newly organized Eastern Kentucky Railway its railroad, furnaces, and acres of coal, iron, and timber.

The original intention of Thayer and Hunnewell was to extend their railroad to a junction with the Southern Atlantic and Ohio at the breaks of the Big Sandy River in Pike County, Kentucky. They also intended to bridge the Ohio River at Riverton to connect with the Scioto Valley Railroad and then build from the north bank of the Ohio to Lake Erie. Such a plan would have opened up the vast natural resources of Eastern Kentucky for a much earlier development of the hills.

In 1857, Nathaniel Thayer became head of the Boston investment firm John E. Thayer and Brother following the death of his brother, John. Nathaniel Thayer gave generously to universities and causes throughout New England. Because he held the majority of railroad stock, Nathaniel Thayer became the first president of the Eastern Kentucky Railway in 1870, and he held that position until his death on March 7, 1883. H. H. Hunnewell was president of a couple of railways in Illinois and Missouri, but he is never mentioned as having dealings with the Eastern Kentucky Railway outside of the initial investment. It would seem that he passed that down to his son, Walter, who was named after H. H. Hunnewell's father. A family friend and Eastern Kentucky Railway vice president, Col. H. W. Bates of Cincinnati, became the second president. Upon his

death in the early 1900s, his son, Sturgis Bates, became president and held that position until the company was removed from the books in the mid-1930s. Sturgis lived the remaining years of his life in Ashland, Kentucky.

Eventually a city named after Walter Hunnewell was formed near the Greenup furnace. The furnace and the town were called Hunnewell. This was nothing new; H. H. Hunnewell had towns named after him in Missouri and Kansas. Nathaniel Thayer had the honor of having Thayer, Missouri, and Thayer, Kansas, named after him. Because of their generosity, both had buildings at universities and in towns named in their honor.

For almost 70 years, the tracks, bridges, and tunnels served the residents of Greenup, Carter, and Lawrence Counties in Eastern Kentucky. The railroad helped produce employment besides farming and hunting, and it gave people an opportunity to travel beyond the farm or nearest store. The railroad was a social center for rural Eastern Kentuckians. It became one of the first railroads in the region, and like many others that followed it, the Eastern Kentucky Railway would experience that last ride into the past—or would it?

Many people discussed or recorded their memories of the Eastern Kentucky Railway. Fred Duncan, the Webbville agent, discussed his experiences regarding the railroad with his daughter Helen, and he recorded some of his duty experiences for pension purposes. Author Jesse Stuart wrote an article about the Eastern Kentucky Railway in the August 1937 issue of *Esquire* magazine. In 1968, he wrote the children's book *A Ride with Huey the Engineer*, which drew upon some of his memories of favorite Eastern Kentucky Railway engineer Huey Cranyon. The late David Spencer recorded the stories he remembered hearing as a boy from his father, George, and others. Spencer recorded them in his newspaper articles from time to time. For several weeks, he took readers on a ride on the Eastern Kentucky Railway through his column. Jim Allen interviewed people, gathered artifacts, and helped to start the Eastern Kentucky Railway Historical Society. Many of those artifacts are on display today at the McConnell House in Wurtland, Kentucky. The Eastern Kentucky Railway Historical Society membership has rarely peaked above 40, and many of the members are senior citizens, but as a group, they have erected Kentucky historical markers along the old rail line. Currently there are markers in Greenup, Argillite, Hunnewell, Grayson, and Webbville. Future markers are planned for Hitchins and Willard. Their goal is simple: to keep the memory of the Eastern Kentucky Railway steaming on. If you are interested in joining the Eastern Kentucky Railway Historical Society, dues are $10 a year, and more information is available at www.ekrailroad.com.

One

ARGILLITE MINING AND MANUFACTURING COMPANY

Argillite is named for the mineral argillite, which was mined in Eastern Kentucky in the early 1800s. Native Americans mined and used the mineral to make jewelry and other useful items for several hundred years prior. The town Argillite had several blast furnaces, iron and coal deposits, and the Little Sandy River, which made it and surrounding areas desirable for business. Thus, in 1865, the Argillite Mining and Manufacturing Company purchased 25,000 acres of land for development. In less than a year's time, the company name was changed to Kentucky Improvement Company.

The railroad of the Kentucky Improvement Company had a track of 5-foot gauge with rails weighing 50 pounds per yard. The rolling stock in 1867 included 3 locomotives, 1 passenger car, 36 freight cars, and 44 coal cars. It is also believed that the Kentucky Improvement Company owned at least two barges to transport their rolling stock across the Ohio River from Riverton.

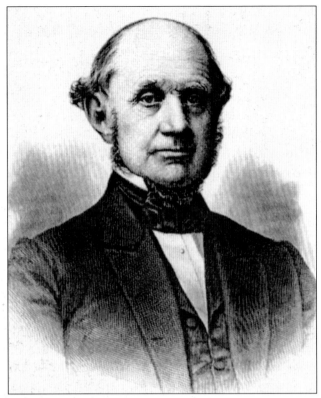

Nathaniel Thayer became the director of the financial and banking firm John E. Thayer and Brother when John died in 1857. Nathaniel backed several railroad and business ventures from Boston to Kansas City, making him one of the wealthiest men in New England. He was president of the Eastern Kentucky Railway Company until his death in 1883.

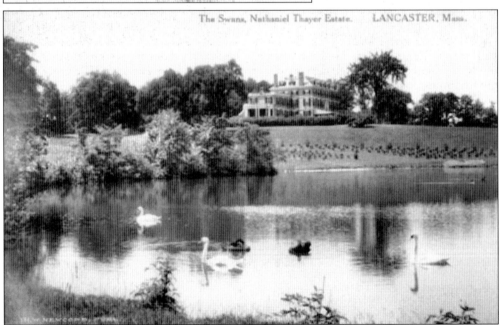

The Swans, Nathaniel Thayer Estate. LANCASTER, Mass.

Swans are swimming in a pond on this postcard of the Thayer estate in Lancaster, Massachusetts, from around 1900. Nathaniel Thayer considered himself a resident of Lancaster and built the mansion in the postcard on virtually the same spot as the previous home. Thayer was careful to avoid removing any of the trees or the old well.

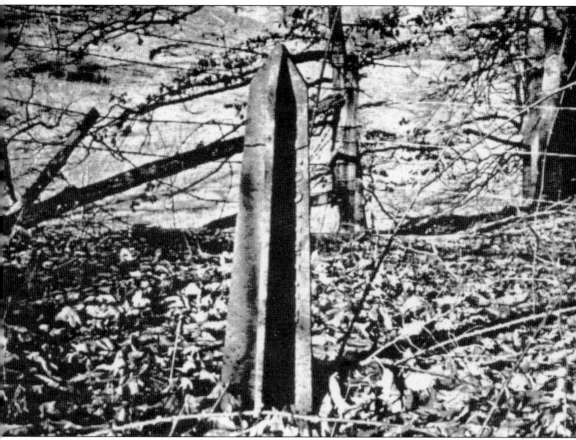

In 1866, the Kentucky Improvement Company marked the boundary of surveyed land with sturdy iron markers, as pictured here on a Greenup County, Kentucky, farm. The markers were the beginning of resource development in the area as well as predecessors to one of the first railroads in Eastern Kentucky.

The charcoal iron furnace industry of Eastern Kentucky reached its maximum development in the mid-1800s. Several decades earlier, furnaces had been constructed adjacent to the Little Sandy River and to what would later be called the Eastern Kentucky Railway. The Argillite and Pactolus furnaces were built in 1822, the Hopewell furnace in 1833, and the Greenup and Pennsylvania furnaces in 1845. In the photograph, the Greenup furnace is in full operation in 1868; it was renamed the Hunnewell furnace at about the same time this photograph was taken. That same year, the Eastern Kentucky Railway extended to this site, several miles south of Argillite and the location of the second furnace purchased by the Kentucky Improvement Company. Pictured on the left is the storage and stock barn, which still stands today. The furnace produced several thousands tons of iron per year until it closed in the early 1880s.

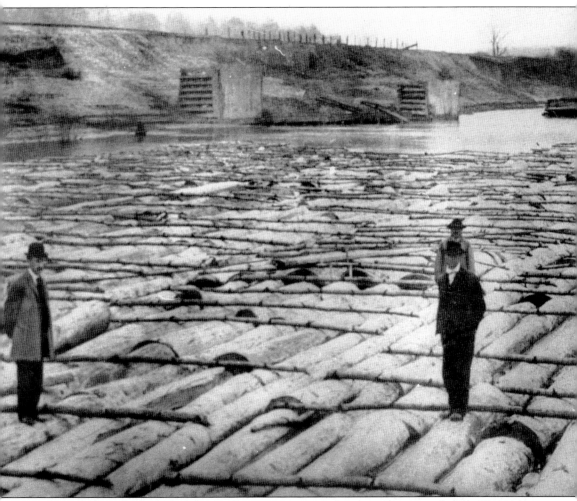

Logging, along with coal and iron, became a source of potential income for the Kentucky Improvement Company. Logs were hauled from as far away as Webbville, unloaded into the Ohio River, and floated down to merchants in Russell, Kentucky, who inspected the wood for market, as outlined in this photograph from 1899.

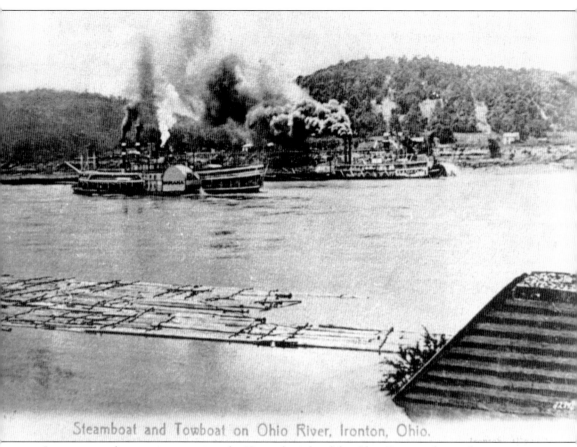

Steamboat and Towboat on Ohio River, Ironton, Ohio.

Logs waiting for transportation on the Kentucky side of the Ohio River and steamboats waiting to load and unload their cargo at the Ironton, Ohio, boat dock are pictured in the 1880s. Ironton operated a couple of larger blast furnaces that contributed to the early and few profitable days of the Eastern Kentucky Railway.

Because of the abundance of natural materials throughout Greenup, Carter, Lawrence, and Boyd Counties, Kentucky, iron furnaces sprang up in areas where both iron and coal could be transported quickly. Pictured in the 1960s is what remains of the old Laurel furnace in Greenup County, which was too far out of the way to be used by the Eastern Kentucky Railway.

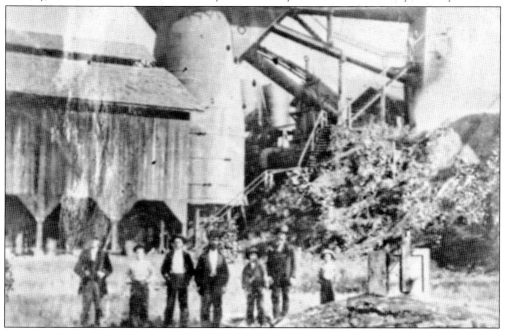

Iron furnaces in the area supplied the Eastern Kentucky Railway with parts, track, and material for bridges. The iron, however, proved to be very poor quality, and the Eastern Kentucky Railway as well as other railroads began to import better-quality tracks from furnaces in Ohio and Pennsylvania. Pictured is what is said to be the last furnace to operate in Carter County.

Many people that lived in the Little Sandy River Valley relied on others to transport their crops to stores and markets, as wagons, horses, and mules were valuable and used widely on the farm, as shown in the photograph from Carter County. The Eastern Kentucky Railway opened up transportation for various crops and for personal travel.

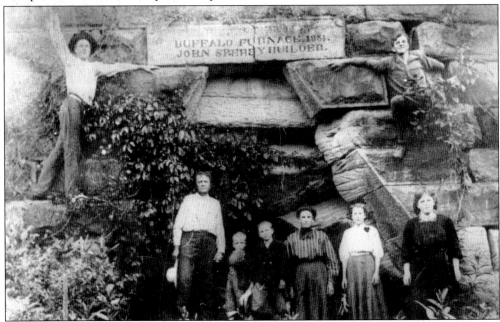

Only two iron furnaces made the Eastern Kentucky Railway a profit in the 1800s: Mount Savage furnace in Carter County and the Buffalo furnace in Greenup County. Neither furnace was on the main rail line, and therefore they had to transfer their product themselves. Pictured is the Spencer family around 1935 at the Buffalo furnace, located in present-day Greenbo Lake State Resort Park.

One of the goals of Thayer and Hunnewell under the direction of the Argillite Mining and Manufacturing Company was to lock and dam the Little Sandy River. A mill and dam were built at the site of the Argillite furnace in 1867. Shown are the remains of the wooden dam structure under the old Little Sandy Bridge near Argillite in 1938.

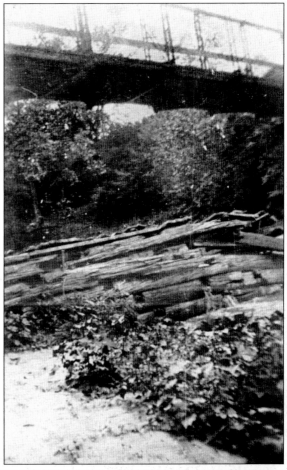

Shown is a group consisting of probable store customers posing for the camera in the 1890s near Riverton. Many individuals used the railway to transport themselves or their goods to larger stores in Greenup, Ashland, Ironton, or Huntington. Without the railway, they had to settle for the smaller selections offered by small community or company stores.

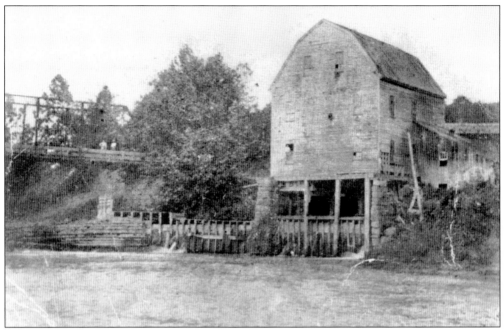

The Argillite mill and dam were photographed around 1900 with a worker in the window and a couple on the bridge. The bridge was used to haul goods from the mill to the Eastern Kentucky Railway depot several hundred yards to the east. The bridge was reinforced over time to accommodate vehicles but was replaced in 1984 for a newer two-lane bridge.

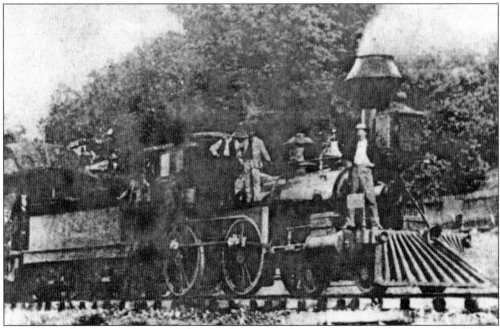

A Kentucky Improvement Company engine is pictured in Riverton two years before the company became the Eastern Kentucky Railway. The photograph is the only one known of a wood-burning round and screen-covered smokestack engine belonging to the railway. The maker was Porter. It is unknown as to what happened to this engine.

Two

RIVERTON, HUNNEWELL, AND GRAYSON

In 1866–1867, six and a half miles of rail from the Ohio River south to Argillite was constructed. Also built were the offices, shops, water tower, turntable, and river loading ramp in Riverton. Riverton was close to Greenup, which would accommodate passenger travel to and from the farms along the Little Sandy River Valley. Farming made up 98 percent of the livelihood for most families along the railroad, and this became a potential means of income for the new railroad.

Stops along this route would include Three Mile, near present-day W Hollow; Simonton, near present-day Argillite Elementary School; and Argillite. Throughout the life of the Eastern Kentucky Railway, people could flag the train down and it would stop almost anywhere to pick folks up or let them off.

In 1868, the railroad was extended several miles south through the stop of Laurel, and a station was established near the site of the Greenup furnace. The railhead and furnace were renamed in honor of the younger of the Hunnewell stockholders, Walter Hunnewell. The shops were moved to this point from Riverton. Immediately a small village began to appear in the surrounding valley, and at one time, Hunnewell came within a vote of becoming the county seat of Greenup. Three iron ore and coal spurs were added to the railroad at this point: Turkey Lick, Coal Creek, and Kane Creek.

In 1870–1871, the railroad was again extended 10.37 miles through the stops of Hopewell and Pactolus to Grayson. On June 10, 1871, the line was officially opened for business in Grayson. The whole town and surrounding area celebrated with a large picnic near where the depot would be located.

During this time, Grayson began to attract new investment capital, and real estate values began to climb. The shops were moved from Hunnewell to Grayson later that same year and enlarged a great deal. The Stinson spur was also added during this time.

In order for the railway to extend from Riverton to Grayson, a great deal of earth moving needed to be done by back and hand.

Shown is the Eastern Kentucky Railway headquarters building at Riverton around 1900. It was from this building that the scheduling, purchasing, and selling took place. Sturgis Bates was the only president of the Eastern Kentucky Railway who actually worked in Kentucky. Most of his decisions came from either here or his home just a mile or so away in Greenup.

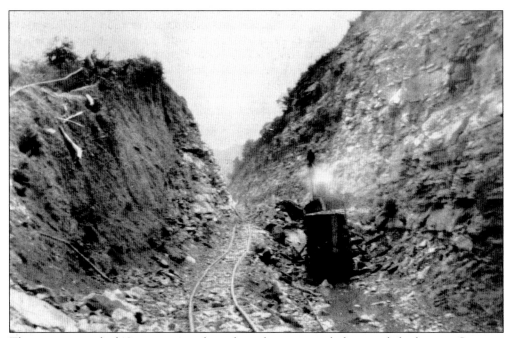

There were a total of 13 major spurs along the railway, not including track facilities in Grayson, Willard, and Webbville. Many of the spurs required the use of a steam shovel to move the earth into a valley on which to lay track, as photographed here near Willard in 1898.

The First National Bank of Greenup, near courthouse square, provided many loans to the Eastern Kentucky Railway. The bank is through the door on the right, and the courthouse is located on the left. Through this courthouse, the bank filed several suits to collect on delinquent railway loans.

Pictured is an Eastern Kentucky Railway Company check from the First National Bank of Greenup in 1911. Several defaults with this same bank led the Eastern Kentucky Railway to enter a permit for abandonment in 1925. The check is dated when friendlier, financially stable times existed between bank and railway.

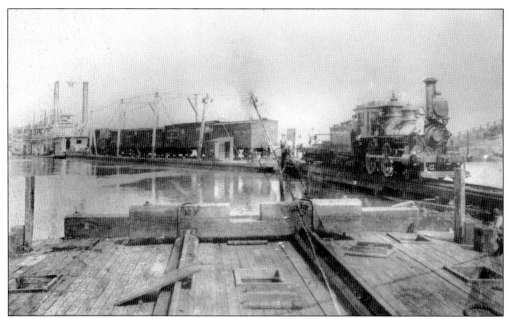

This photograph, taken near Greenup around 1880, demonstrates how dangerous unloading railcars could be. The stern-wheeler had to fight currents to keep the tracks on the barge in line with the tracks on the bank dock in order to be linked. To the right, but not in the picture, is the large bank the engine must transverse; this often required another engine and heavy-duty chain to assist with the steep grade.

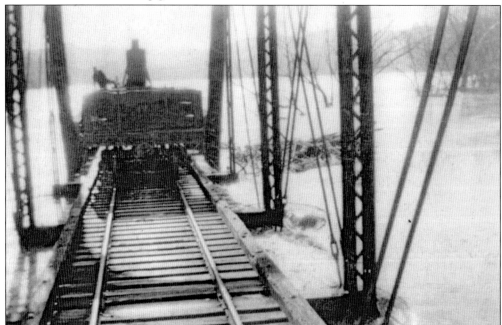

In the 1880s, the railway discontinued use of the Ohio River loading dock at Riverton after flooding left the dock useless, and a junction was added in Carter County. Railcars could make their way through the railroad and onto the new river loading dock, which was built above the river like a half-bridge, as shown in this 1910 photograph.

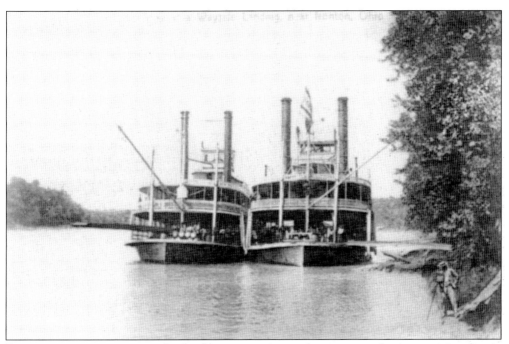

River transportation continued to be the primary means of transporting large quantities of items for communities along the Ohio River and its tributaries, such as the Little Sandy River. Here are two steamboats on the bank of the Ohio side of the river near Riverton in the 1890s.

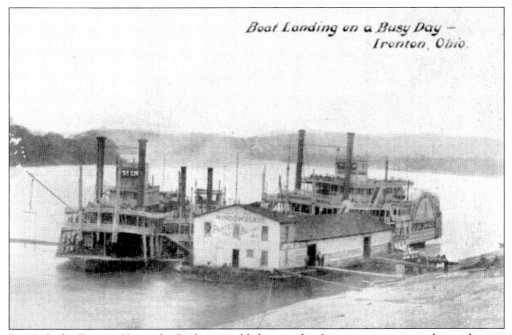

By 1905, the Eastern Kentucky Railway could ship much of its cargo continuously via the two railroads that crossed its line at Riverton and Hitchins. In this postcard from 1900, the stern-wheeler *Princess* and two other boats are wedged in at the dock at Ironton, where a customer could buy paint or a window.

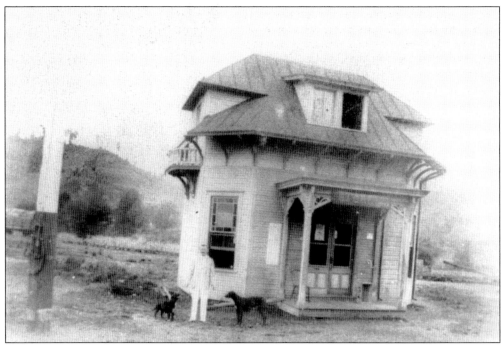

Shown in 1895 is the store at Riverton, which would come to be called Riverton Junction, near where two railroads met. The Eastern Kentucky Railway tracks are in the background. Many people traveling to and from the towns along the EK and the Chesapeake and Ohio (C&O) Railroad transferred trains at this point, just above the Greenup depot.

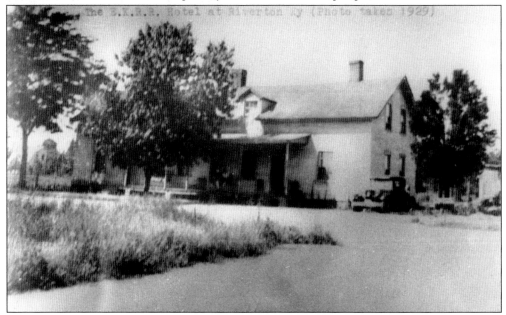

In the beginning, Riverton hosted the Eastern Kentucky Railway offices, shops, houses, and hotel, shown in 1929. Workers could stay on Eastern Kentucky Railway business for a discount when traveling in from any points south to Webbville. Eventually the shops moved farther south, but the hotel and offices remained until the railway was abandoned.

The Riverton depot served the Eastern Kentucky Railway for almost 60 years before abandonment and sale. The depot was used at times as a storage facility and as a depot by the C&O at Riverton. During the early 1930s, Fred Duncan, seen here, made a last visit to the depot.

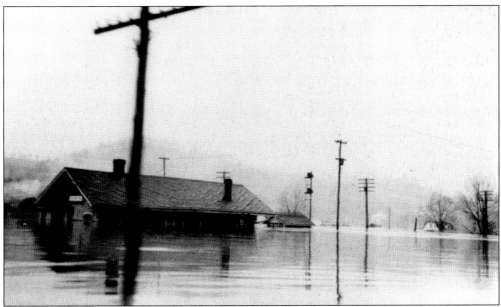

Many of the Eastern Kentucky Railway buildings in Riverton were under constant repair and upkeep due to the number of times the Ohio River went beyond its bank. Several of the buildings were abandoned and demolished after the great flood in 1937. One of the last photographs of the Riverton depot shows the depth of the 1937 flood.

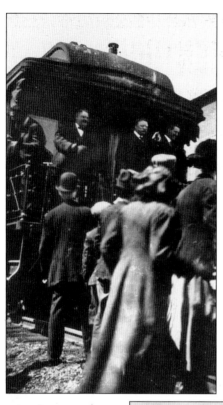

Bull Moose presidential candidate Theodore Roosevelt campaigns from a passenger coach near Riverton in 1912. Roosevelt stopped near Riverton Junction on the C&O track on his way to Cincinnati. This type of railroad campaigning began with Andrew Johnson and continues from time to time today.

Beginning in the 1990s, the Eastern Kentucky Railway Historical Society planned and collected enough money to erect Kentucky Historical Society highway markers commemorating the history of the Eastern Kentucky Railway. Pictured is the first marker, erected in Greenup. The marker is located just off the old U.S. Route 23 bridge on the right going toward town.

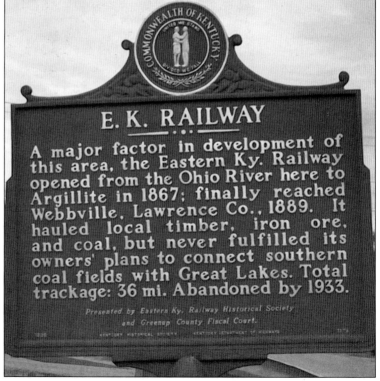

COMMONWEALTH OF KENTUCKY

E. K. RAILWAY

A major factor in development of this area, the Eastern Ky. Railway opened from the Ohio River here to Argillite in 1867; finally reached Webbville, Lawrence Co., 1889. It hauled local timber, iron ore, and coal, but never fulfilled its owners' plans to connect southern coal fields with Great Lakes. Total trackage: 36 mi. Abandoned by 1933.

Presented by Eastern Ky. Railway Historical Society and Greenup County Fiscal Court.

Many railroads in the country rarely if ever scheduled runs on Sunday, but such is not the case with this Eastern Kentucky Railway poster. Many people in rural Greenup, Carter, and Lawrence Counties never saw the Ohio River until they rode the Eastern Kentucky Railway into Riverton. Several described seeing the Ohio River for the first time as someone who first saw the ocean. The big river proved to be a magnet, and the Eastern Kentucky Railway took advantage of it, advertising spending a Sunday on the Ohio River. The railway created several posters mentioning specific events such as a visit of Pres. Rutherford Hayes and the Dewitt hanging in Carter County, which attracted throngs of people from up and down the railway. This poster is the only known Eastern Kentucky Railway advertisement that remains today.

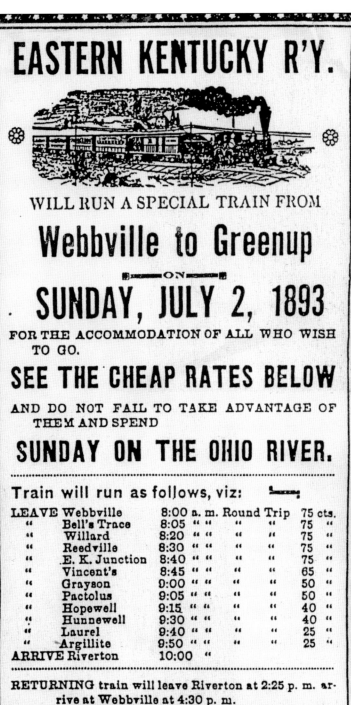

EASTERN KENTUCKY R'Y.

WILL RUN A SPECIAL TRAIN FROM

Webbville to Greenup

ON

SUNDAY, JULY 2, 1893

FOR THE ACCOMMODATION OF ALL WHO WISH TO GO.

SEE THE CHEAP RATES BELOW

AND DO NOT FAIL TO TAKE ADVANTAGE OF THEM AND SPEND

SUNDAY ON THE OHIO RIVER.

Train will run as follows, viz:

LEAVE Webbville	8:00 a. m.	Round Trip		75 cts.	
" Bell's Trace	8:05 " "	"	"	75 "	
" Willard	8:20 " "	"	"	75 "	
" Reedville	8:30 " "	"	"	75 "	
" E. K. Junction	8:40 " "	"	"	75 "	
" Vincent's	8:45 " "	"	"	65 "	
" Grayson	9:00 " "	"	"	50 "	
" Pactolus	9:05 " "	"	"	50 "	
" Hopewell	9:15 " "	"	"	40 "	
" Hunnewell	9:30 " "	"	"	40 "	
" Laurel	9:40 " "	"	"	25 "	
" Argillite	9:50 " "	"	"	25 "	
ARRIVE Riverton	10:00 "				

RETURNING train will leave Riverton at 2:25 p. m. arrive at Webbville at 4:30 p. m.

❀ PROCURE TICKETS FROM AGENTS. ❀

R. B. LEEDY, Sup't.

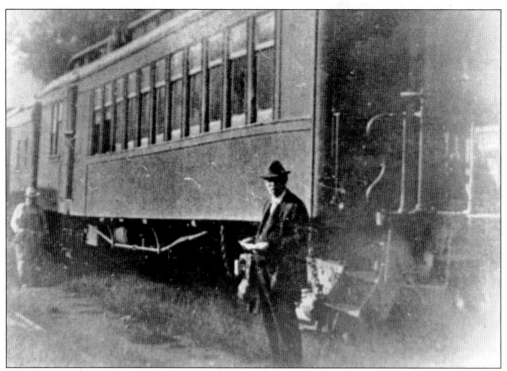

Pictured about 1923 is Capt. William J. McKee, longtime Eastern Kentucky Railway conductor, with his hand on his watch. Captain McKee purchased a farm, which included a house, from the Eastern Kentucky Railway. The house has been remodeled and today is a beautiful example of the architecture from that bygone era.

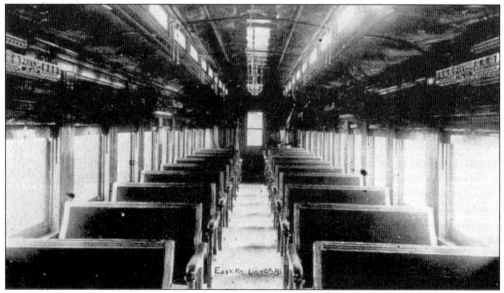

The passengers of the railway had padded cloth seats on which to sit after giving their tickets to Captain McKee. In the summer, the windows opened up, providing a breeze mixed with ash; during the winter, a small wood stove at the least-used end of the car provided heat. Pictured about 1920 is the interior of an Eastern Kentucky Railway coach.

EASTERN KENTUCKY RAILWAY COMPANY.

This Memorandum *must be punched before it is separated*, and this *colored* half delivered to the passenger paying fare to the Conductor. *Punch–Marks* must indicate THE STATIONS from and to which Fare is Collected, Amount Paid and Date. **Not Good for Passage.**

H. W. BATES, Manager.

Jan.	Feb.	Mar.	Apr.	May.	June.	July.	Aug.	Sept.	Oct.	Nov.	, c.
17	18	19	20	21	22	23	24	25	: 27	28 29 30 31	1878
1	2	3	4	5	6	7	8	9	10 11 12	13 14 15 16	18.

DOLLARS. 1 2 3 4 5 CENTS. 5 10 15 20 25 30 35 40 45 50
1 2 3 4 5 5 10 15 20 25 — 35 40 45 50

EKR 79 21 125 Am't Paid Punch O For Half Fare.

SOUTH — Riv... Jn — 3-Mile — Worthing's — A...lite — Laurel — Hunnewell — Deerling's — Hopewell — Anglin's — Pactolus — Grayson — Vincent's — Mt. Savage — Readville — Willard — NOR... Punch O

On this December 29, 1879, punch ticket are the stops and prices along the Eastern Kentucky Railway line. Notice several of the stops that are not on the main schedule: Worthing's, Deerling's, and Mount Savage, along with other familiar places. The prices ranged from 5¢ to $5.

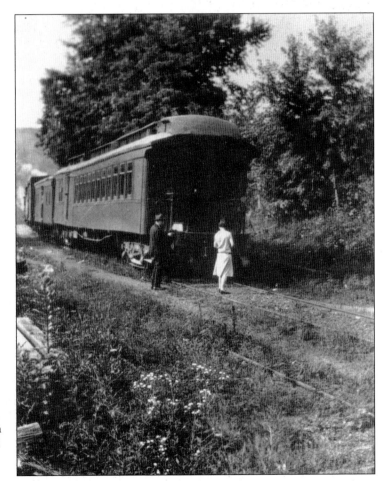

Capt. William J. McKee is shown with a young woman leaving the passenger car in this photograph taken about 1925 near the Three Mile station. The Eastern Kentucky Railway was very accommodating to passengers loading and unloading from the train. The profits made from passenger service were unable to rescue the railway from decades of deficits, and the northern end was abandoned in 1926.

Two young Eastern Kentucky Railway employees stand ready to get back to their jobs after posing for this photograph. William McKee, the conductor, is on the left, and engineer Huey Cranyon is on the right. This is the only known photograph of the real Huey the Engineer, taken about 1879.

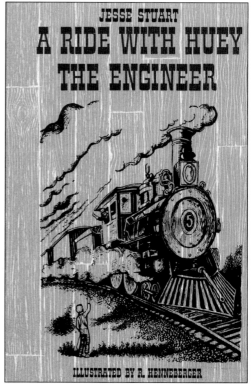

JESSE STUART
A RIDE WITH HUEY THE ENGINEER
ILLUSTRATED BY R. HENNEBERGER

A Ride with Huey the Engineer was published in 1966 by McGraw-Hill. The book was out of print for several years but can now be purchased from the Jesse Stuart Foundation, Inc., in Ashland, Kentucky. The reprinted version also contains a brief history with photographs of the Eastern Kentucky Railway.

Jesse Stuart has published many short stories, novels, and poems throughout his life in Greenup County. He was born just a couple of miles from the Three Mile stop in 1906. Stuart died in 1984 in Ironton, Ohio. He first recorded his recollections of the Eastern Kentucky Railway in a popular magazine in 1937.

To Imogene Crawford Felty,
you've ridden many
a time on Huey's
train – the Old Eastern
Kentucky Railway. You
will remember Huey –
He's train is no
more now! Only
the old tunnels
under the hills and
a few marks where
it used to be.
It's a pleasure to
sign this for you.
Jesse Stuart
Jan. 8th 1968

Stuart signed this copy of *A Ride with Huey the Engineer* in 1968. Notice that he mentions Huey and the railway and that by the time he signed this book, much of the Eastern Kentucky Railway and any of its physical characteristics had disappeared. Like many young boys that lived along the railway route, James, Jesse's younger brother, yearned to be like Huey and operate a steam locomotive.

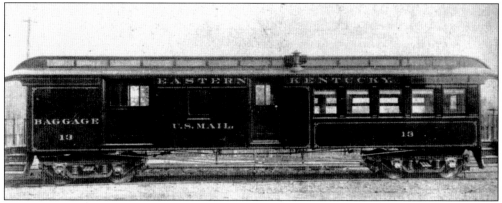

From 1870 to the mid-1920s, the Eastern Kentucky Railway received payment for carrying mail between Riverton and Webbville. This proved to be the only reliable profit for the railway throughout its history. Shown is car or combine No. 213, which tripled as a mail car, baggage car, and passenger car.

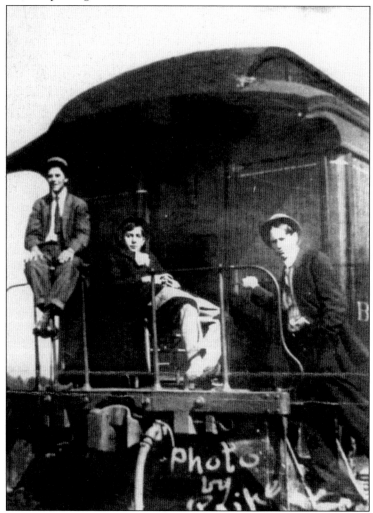

Three young men pose on the back of the Eastern Kentucky Railway mail and baggage car near Riverton in the early 1920s. Many young men in the area dreamed of one day trading their hard work in mines and on farms for the railroad and living a life along the rails.

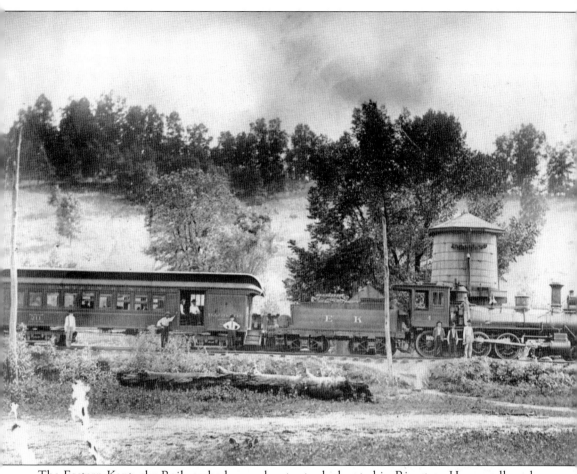

The Eastern Kentucky Railway had several water tanks located in Riverton, Hunnewell, and Willard. In the late 1800s, the Hunnewell water tank was relocated to Barretts Creek, about a mile north of Grayson, and later to a point about one mile south of Grayson. Pictured is the second No. 4 engine, which was purchased in 1888 from the Pennsylvania Railroad. Here at the Barretts Creek water tank, a spring on the hill behind and a well at the base of the water tank provided water all year. A hand pump was located at the base of the water tank within the housing and was pumped for several times each day. This locomotive proved to be a dependable workhorse for the Eastern Kentucky Railway and was finally decommissioned in 1912 and sold for scrap that same year, along with the second No. 5 and No. 6 engines.

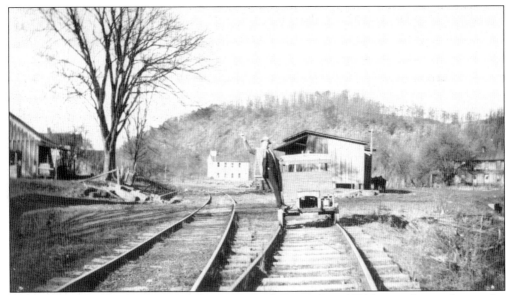

This photograph (also on the cover) shows George Spencer about 1921 having fun on the speeder at Argillite. To the left is the Pierce house, and on the right is the mouth of Culp Creek Road, with the house of Bill Riggles to the right of the Argillite depot behind Spencer. The Argillite Mills is several hundred yards to the left of the photograph.

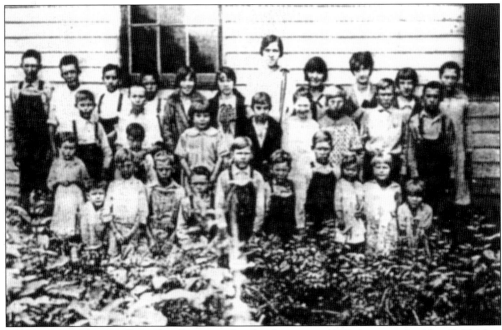

Children from the Argillite schoolhouse gather for this spring 1927 photograph. Alva Baldridge, standing on the far left, remembers watching the engine pass through the window at center. He described riding the railway as the grandest ride he had ever taken in his life. Alva worked for and retired from the C&O Railroad.

Shown coming out of Argillite Tunnel and headed for the depot is the Eastern Kentucky Railway engine know as "Lulla Belle." She was one of the last engines that ran the complete route of the entire 36-mile line. Brady Hern was the engineer, Ed Webb the fireman, and Bill Hern the conductor.

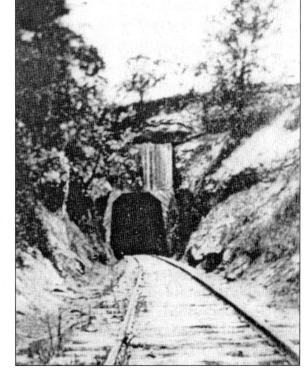

Argillite Tunnel was the third tunnel built by the Kentucky Improvement Company around 1868. Like all of Eastern Kentucky Railway's eight tunnels, this had a natural rock roof, which decreased the likelihood of rock falls. The north side of Argillite Tunnel is the only tunnel entrance visible from the highway today. The other seven have collapsed and are flooded.

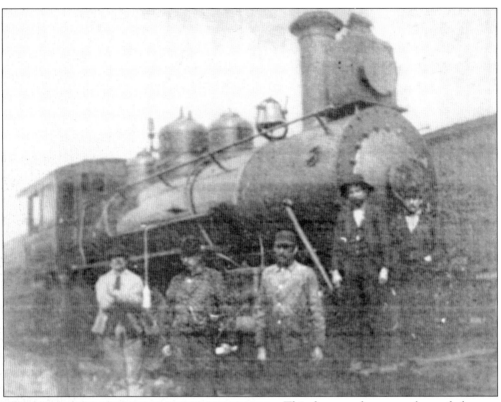

This depot and store are located almost in the center of the line between Callahan Tunnel and Ramey Tunnel. The men are unknown except for Capt. W. J. McKee, second from left, dressed in lighter-color clothes. He began working for the Eastern Kentucky Railway in 1873 at the age of 15 as a gin hand.

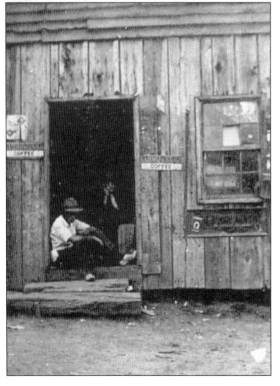

The Laurel stop was between Argillite and Hunnewell just on the north side of Sand Suck Creek. The location was at one time a loading point for timber from surrounding hills but later became just a quick stop for passengers and mail. Pictured is the Laurel store, which served as the depot for the railway.

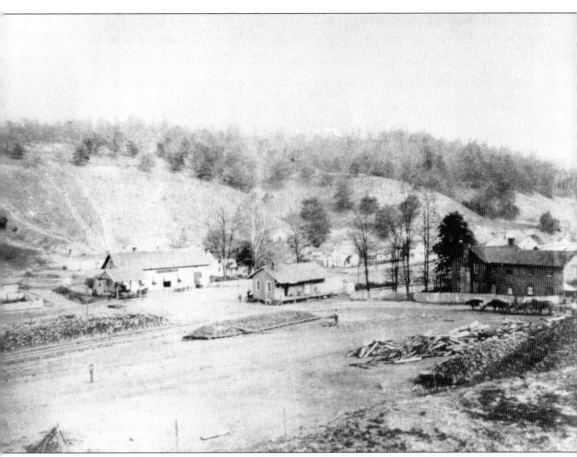

This photograph of the town of Hunnewell around 1890 shows the former shops just behind the depot, across the tracks from this view. The hotel or inn is on this side of the tracks to the right, along with a number of homes, and the Hunnewell store is just behind the inn.

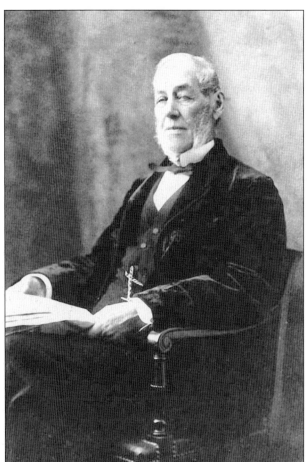

Horatio Hollis Hunnewell was the son of a well-respected Boston physician, Dr. Walter Hunnewell (1769–1855). H. H. Hunnewell, philanthropist and hobby botanist, is thought to be the first person to introduce rhododendrons to the United States. He also invested in several railroads throughout America, resulting in towns in Missouri and Kansas being named in his honor.

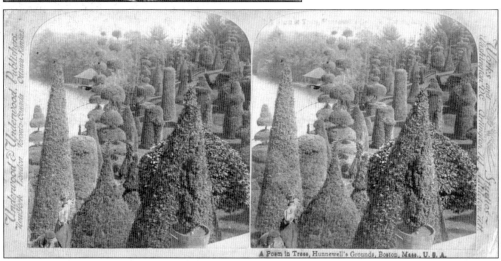

Pictured is a stereo view of the Hunnewell grounds near Boston in 1894 titled "A Poem in Trees." This illustrates Hunnewell's passion for various kinds of trees and the great wealth he had compared to people along the Eastern Kentucky Railway. Hunnewell handed all board decisions and responsibilities over to his son, Walter, in the early 1870s.

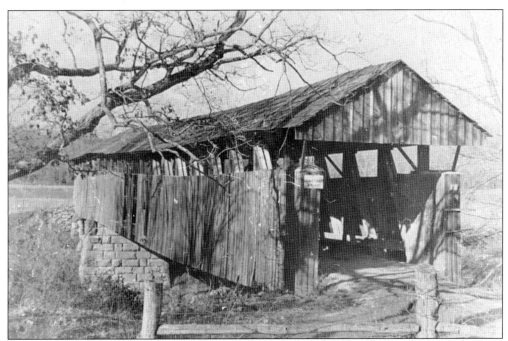

Built in 1880, the Oldtown covered bridge opened up access from the western side of the Little Sandy River to the eastern side, which was several miles from Hunnewell. It was easier to walk or ride several miles to Hunnewell than to travel four times that distance to Pactolus. The 187-foot, double-post covered bridge is still standing today.

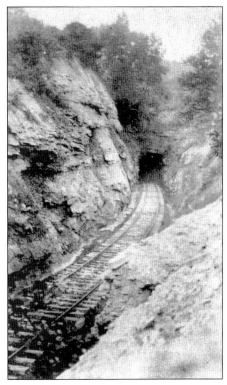

Big Tunnel was the largest of the eight tunnels along the Eastern Kentucky Railway line at 1,230 feet long. Pictured is the Hopewell side of Big Tunnel. A watchman with a small hand car was employed to watch for falls, remove rock if possible, and warn trains if necessary.

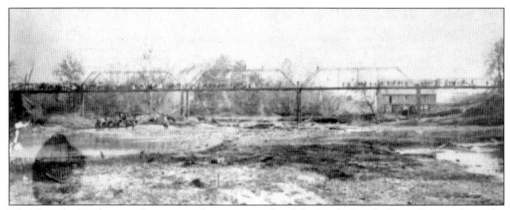

The Pactolus Bridge eased access to the eastern side of the Little Sandy River for people at the Eastern Kentucky Railway stop not far from the western side. The bridge was built in 1899 by the Lafayette Bridge Company and for a time was the longest of its type in Kentucky.

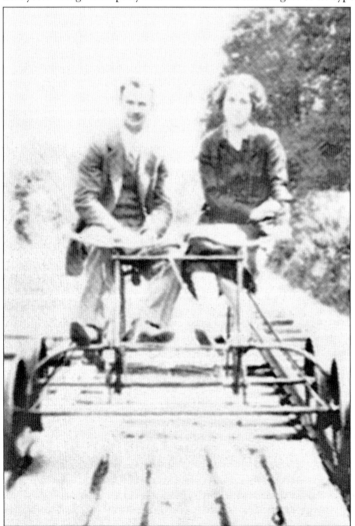

A couple enjoys some time along the quiet Eastern Kentucky Railway in the mid-1920s. Apparently, before the tracks were taken up from Grayson through this point, people in Pactolus rode this four-wheeled velocipede rail pump cart. This was a rare velocipede, as most were three-wheeled, not four.

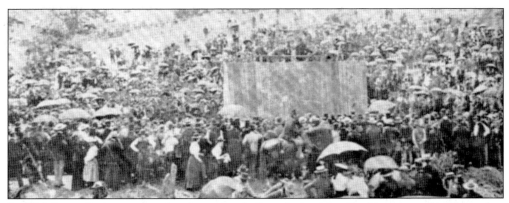

In 1896, James Dewitt was tried and convicted of murdering his wife after a quarrel in November the year before. The hanging was to be the last execution in Carter County and was advertised as a big event by the Eastern Kentucky Railway. As photographed, nearly 5,000 attended the execution south of Grayson, about a hundred yards away from the tracks, on May 21.

An early photograph of Grayson shows the terrible condition of roads through town. At times, the roads in rural areas of eastern Kentucky deteriorated to the point of being impassable. Walking to catch the Eastern Kentucky Railway was a more welcome task; note the condition of the walkways in the photograph.

The Grayson depot is pictured in this undated photograph. The depot was built in 1871 and was the center of attraction; a holiday was declared when the railway came to town. A big picnic was staged, and the day was spent dancing. The scene was much different in 1933, when the depot was abandoned by the Eastern Kentucky Southern Railway.

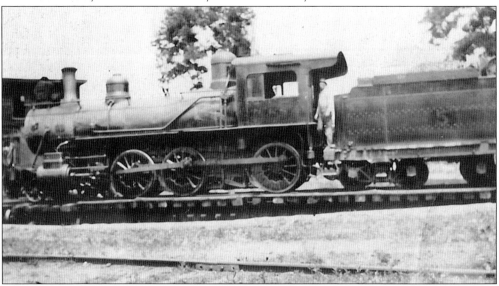

Malcomb Partlow is in the cab of the second No. 5 engine on the turntable in Grayson around 1909. The engine was built by Schenectady in 1892 and purchased used from the C&O by the Eastern Kentucky Railway in 1901. The engine was scrapped in 1912 with several other engines.

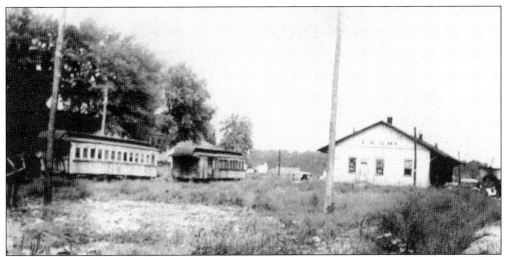

The Grayson depot and coaches pose for this 1934 photograph shortly after abandonment. The coaches shown at the depot, as well as the metal in storage at the shops located about 50 yards away, were sold for less than scrap price in the mid-1930s. Very few metal items from the Eastern Kentucky Railway exist today.

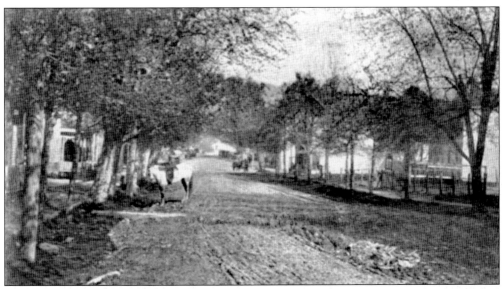

Horses and trees line a Grayson Street pictured not long after the Eastern Kentucky Railway laid track in the 1870s. During this time, real estate values climbed, and the population increased greatly. The Little Sandy River ran nearby, and the city was located in the center of coal, iron, and timber.

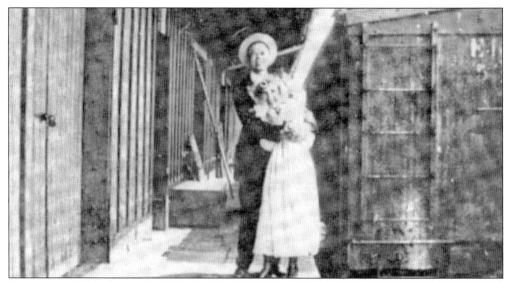

A young couple finds comfort in each other's arms on the platform at the Grayson depot around 1925. Note the "E.K." on the boxcar to the right of the couple. The depot was a storage point for unused cars so as not to congest the shops, which were nearby.

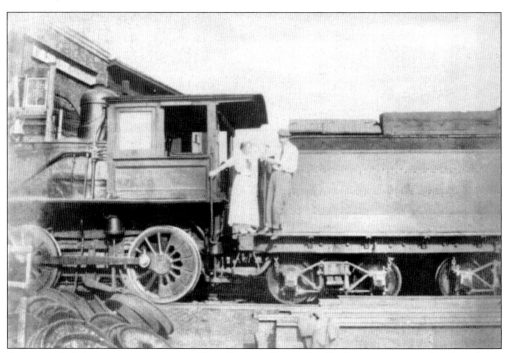

A man is helping a young woman off an Eastern Kentucky Railway engine at the first shops building around 1920. "E.K.R. Shops" can be seen over the entrance door of the partially brick structure. This building was built around 1885 and burned down around 1930; it was replaced within months.

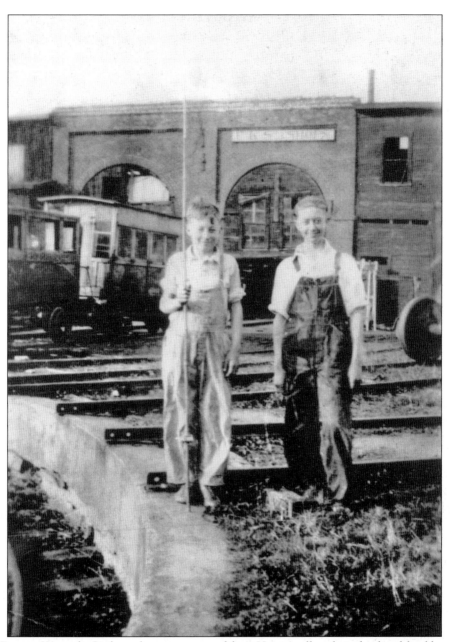

The Eastern Kentucky Railway shops were moved from Hunnewell to their third and final location in Grayson in the 1870s. The shops remained property of the Eastern Kentucky Railway until 1929, when the railway was sold and became the Eastern Kentucky Southern Railway. When the shops burned around 1930, the replacement building was less than half the size. Pictured are Cecil Callahan on the right and an unidentified young man on the left. Note the sign over the door, "E.K.S Shops." The photograph was taken not long after the southern portion of the track took over control, and the gas-powered passenger cars, or "Blue Goose," can be seen in the background. The boys standing at the Grayson turntable, about 25 yards in front of the shops building, are ready to go fishing in the Little Sandy River. After total abandonment, all metal was removed from the turntable for scrap, and the hole was filled in.

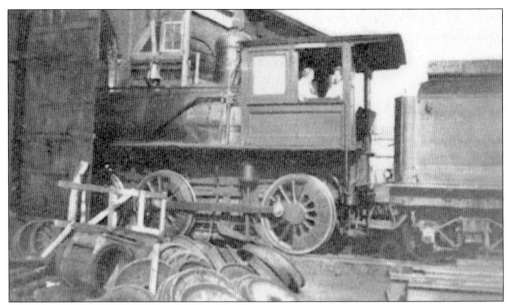

This photograph shows an Eastern Kentucky Railway engine ready to enter the shops building for possible maintenance, while iron wheels populate the shop yards around 1920. After abandonment, the Eastern Kentucky Southern Railway sold everything metal to recover the cost of purchasing the railway from the Eastern Kentucky Railway.

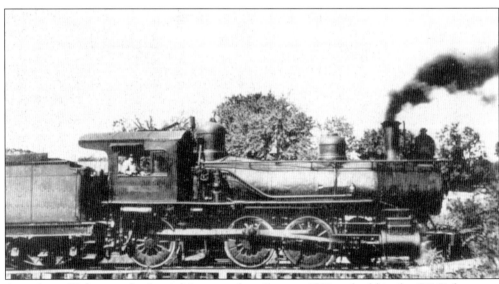

A product of Schenectady, this 4-6-0 was made in January 1892 and sold to the C&O that same year as No. 121, class F-10. The Eastern Kentucky Railway purchased it in April 1912, naming it the second No. 5. Here the No. 5 is on the Grayson turntable around 1919.

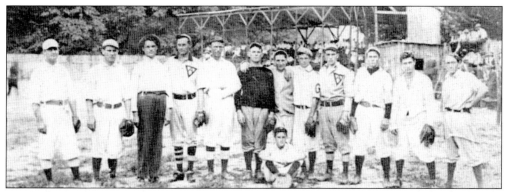

Baseball players from Ashland, Greenup, Grayson, and Olive Hill used the Eastern Kentucky Railway to travel from their home fields to play several different teams in the Eastern Kentucky area. Posing in this early-1900s photograph are opposing players from Ashland and Grayson, friendly in front of the camera on a Grayson field.

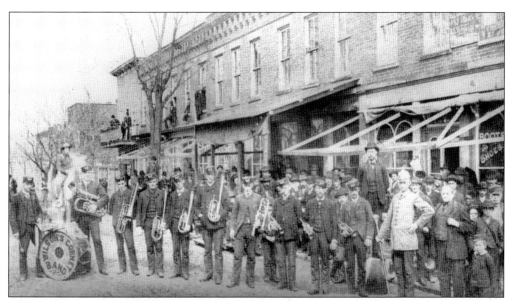

During the opening of the Eastern Kentucky Railway in Grayson in 1871, Greenup's Wilson's Cornet Band traveled the 22.5 miles from Riverton to provide music for the large picnic on opening day. Bands like this, photographed in 1880s, traveled via the railroads to play on special occasions and to march in various types of parades.

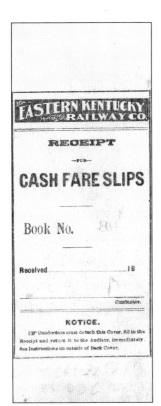

The Eastern Kentucky Railway had net earnings in the 1800s of as little as $1,611 a year and as much as $11,638 a year. In the 1900s, it was as much as $17,625 to as little as $81. Pictured is a small paper receipt for cash fare slips. Conductors filled these slips out and returned them to the auditor immediately for safekeeping.

This Kentucky Historical Society historical highway marker was purchased by the Eastern Kentucky Railway Historical Society and is located near the city park in Grayson. This is the former site of the Grayson depot and shops. Two more markers are planned for former stops in Carter County at Hitchins and Willard.

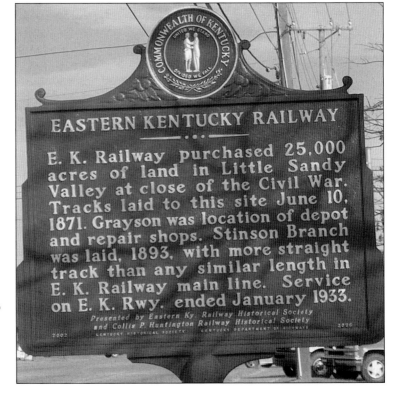

Three

HITCHINS TO WILLARD AND WEBBVILLE

In early 1873, the Eastern Kentucky Railway entered into a contract with the owners of two large blast furnaces in Ironton, Ohio. The owners of the blast furnaces had purchased large tracts of land in the Willard, Kentucky, area of Carter County. The large quantity of the coal and iron ore was thought to be of high quality. The contract called for the right to ship large quantities of coal and iron ore via the Eastern Kentucky Railway from this point to Riverton, where they would be loaded onto barges and ferried for transport across the river to Ironton. To meet their part of the contract, the Eastern Kentucky Railway laid down 11.3 miles of track from Grayson through Vincent, Anglin (later Hitchins), Reedville, and Butler to Willard. The track opened for business in April 1874. In 1876, the owners of the blast furnaces ceased shipment of the coal and iron ore, claiming the quality was too low for their furnaces. The Eastern Kentucky Railway filed suit that same year and received a favorable judgment in the form of land and mineral rights in the Willard area.

Being the only railroad in the area, the Eastern Kentucky Railway transported much of the merchandise coming into Greenup, Carter, Lawrence, Johnson, Martin, Pike, Floyd, Elliott, Morgan, Rowan, Magoffin, Knott, and Letcher Counties. This coupled with the transporting of goods from the Mount Savage and Buffalo furnaces resulted in the most prosperous time for the Eastern Kentucky Railway.

At the behest of timber owners and loggers in western Lawrence County, Kentucky, the rail line was extended another 1.77 miles from Willard through Bellstrace to the final extension of main track at Webbville in 1889. Of the total main line of 36 miles, 17.08 ran through Greenup County, 17.59 through Carter County, and finally 1.33 into Lawrence County.

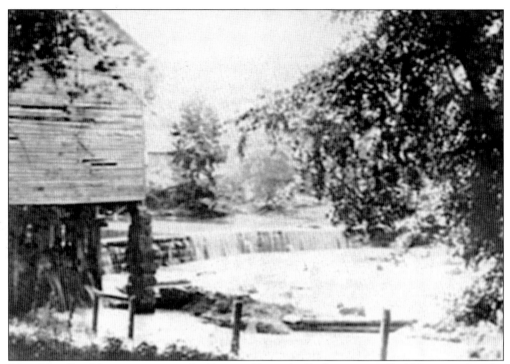

The old mill at Vincent was near the Eastern Kentucky Railway stop called Vincent after the Vincent family. The depot was very small compared to the larger depots at Riverton, Grayson, and Webbville. This continued to be a railway stop until the gas-powered rail bus Queen last ran in January 1933.

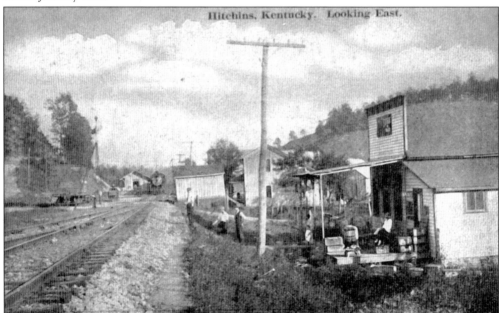

Hitchins, Kentucky. Looking East.

Before the name Hitchins was used, the town went by Anglin and EK Junction. In this postcard from the 1930s, tracks are shown running east in Hitchins. Note the Hitchins depot centered in the back. The depot at one time served the C&O and the Eastern Kentucky Railway.

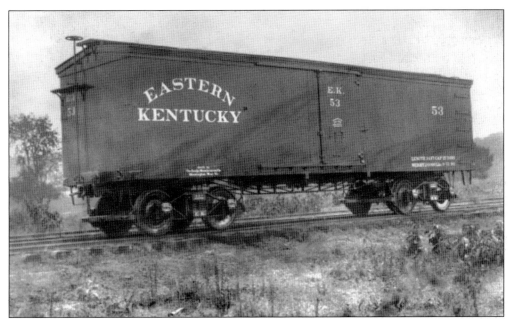

This Eastern Kentucky Railway boxcar was photographed near Hitchins around 1915. In the late 1800s, liquor dealers from Greenup County would find creative ways to send their merchandise to patrons in Carter County. On boxcars like the one pictured, these dealers would send jugs boxed up and labeled as anything not suspicious, such as hats or shoes. The train during this time was commonly referred to as the jug train.

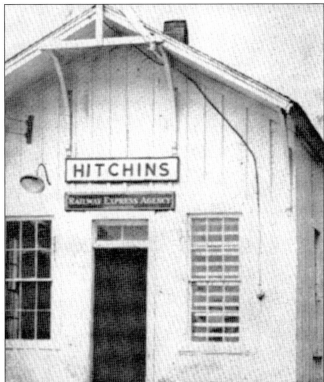

The Hitchins depot is pictured about the time the Eastern Kentucky Southern Railway abandoned its section of track. When the C&O and Eastern Kentucky Railway came into Hitchins together, the Eastern Kentucky Railway was allowed right-of-way because of the fact that it was the first railway in the area.

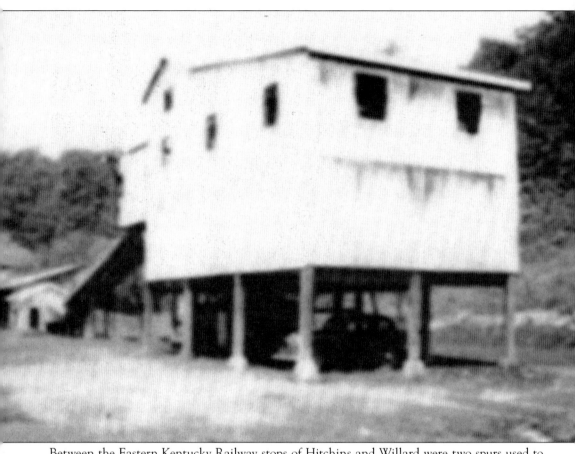

Between the Eastern Kentucky Railway stops of Hitchins and Willard were two spurs used to mine coal, the Huffs Run Spur and the John's Run Spur. Hitchins had several coal mines that experienced some limited success and therefore were around for several years. Pictured is a building that remains from the Joyce Coal Company.

Most of the bricks that made their way out of the Hitchins brick plant were transported via railcar, as shown in this 1920s photograph. Comparatively few made their way down the main line of the Eastern Kentucky Railway for transfer to other railroads and barges near the Ohio River. Most were transported via the C&O's line.

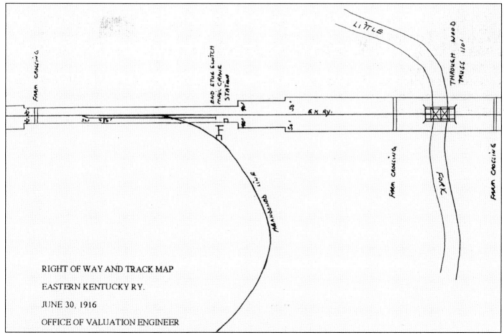

The Reedville station was one of the few Eastern Kentucky Railway stops that did not have a building depot. According to this 1916 engineer drawing, the stop was little more than stopping just anywhere along the tracks, except this stop had a crane station to pick up and drop off the mail. Reedville continued to be a stop for the railway until the end.

The John's Run mine, pictured in the early 1900s, was one of the largest coal mines owned by the Eastern Kentucky Railway. The mine was an award of the court back in the 1870s, after the owners of two blast furnaces in Ironton, Ohio, refused to use this lesser-quality coal in their furnaces.

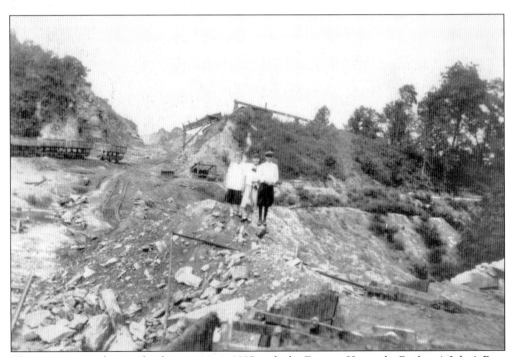

Three young people pose for this picture in 1927 with the Eastern Kentucky Railway's John's Run coal mine in the background. Prior to the commercialization of coal brought about by the Eastern Kentucky Railway, coal was hauled to homes and iron furnaces via mules. This coal mine was located between the stops of Reedville and Willard in Carter County, Kentucky.

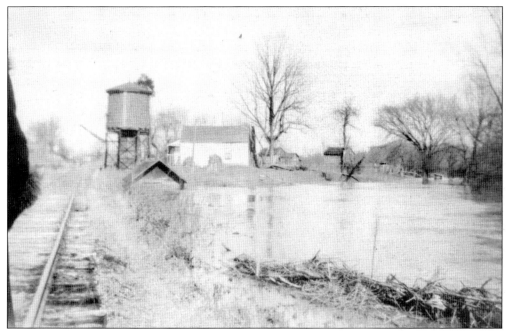

The Willard water tank comes into view as a person makes way past the pond area on the right, toward the water tank and store. Willard was the scene of two unique crimes in the 1800s. A Porter man was taken from jail and hanged from one of the track bridges, and a bank robbery occurred in which the railway was the method of getting away.

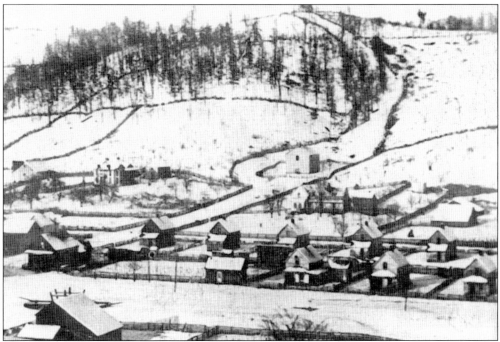

Willard is seen as it looked in the 1880s in this postcard of snow. Several of the homes from the photograph are discernible today. Willard had two track sidings of 1,002 feet and 829 feet in length. There was a 282-foot spur track connecting the south end and leading to a turntable.

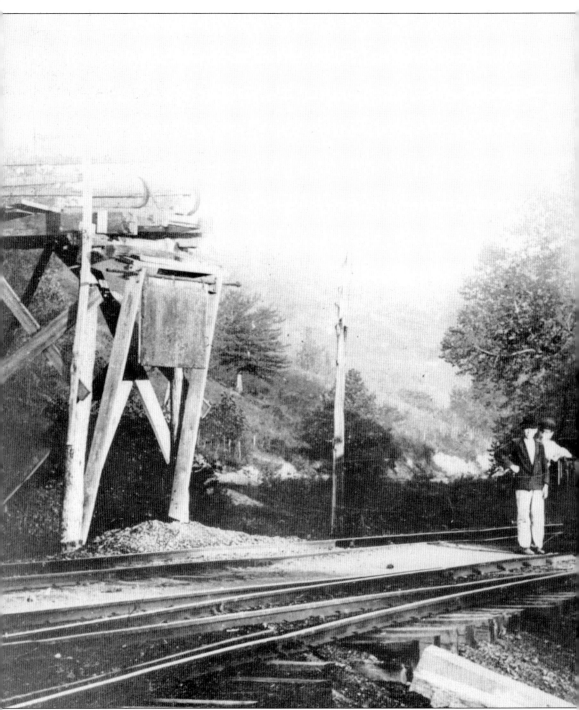

The second engine No. 4 stops for water at the Willard water tank around 1910, as several local miners gather with three Eastern Kentucky Railway employees. Willard was one of the sure investments for the railway. The coal mines nearby produced enough coal and saw a few profitable years despite the lower grade of coal. A short distance south of this station, the Lost Creek Branch took off to the east. About 600 feet south of the bridge over Dry Fork and immediately south of

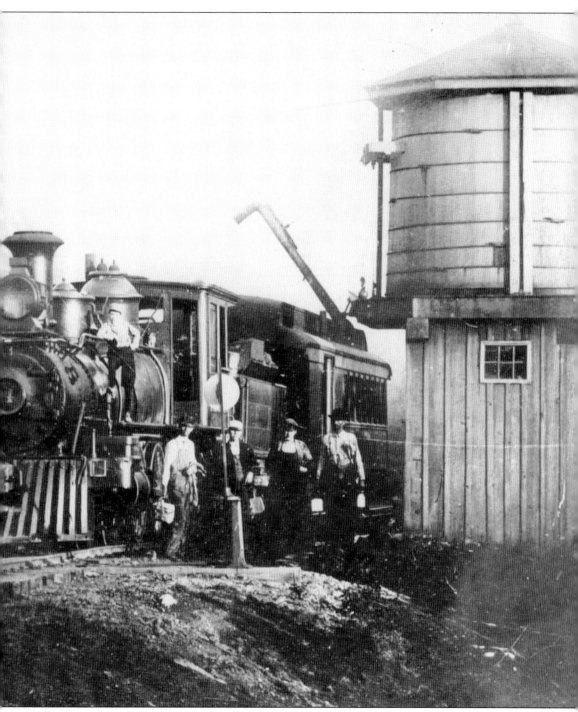

Willard, a spur track about 2,500 feet in length left the main track for the north, terminating just north of the Willard depot on the opposite side of Dry Fork. Willard was one of the busiest cities on the Eastern Kentucky Railway. Willard differed from all other towns along the railway except Hunnewell because both towns were owned and operated by the Eastern Kentucky Railway.

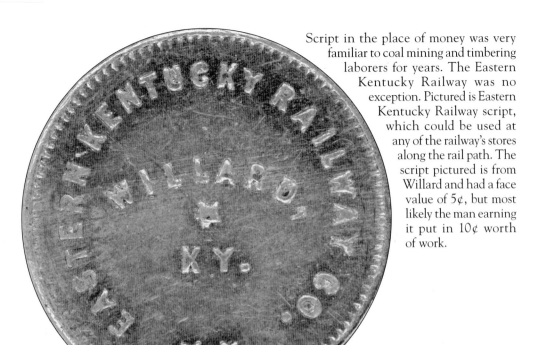

Script in the place of money was very familiar to coal mining and timbering laborers for years. The Eastern Kentucky Railway was no exception. Pictured is Eastern Kentucky Railway script, which could be used at any of the railway's stores along the rail path. The script pictured is from Willard and had a face value of 5¢, but most likely the man earning it put in 10¢ worth of work.

Pictured on one of several wooden Eastern Kentucky Railway trusses, the Duncan family and friends take a leisurely walk along the rail line near Webbville around 1919. On the northern end of the Eastern Kentucky Railway, trusses were made primarily of iron. Several near the Webbville stop were made of iron or wood.

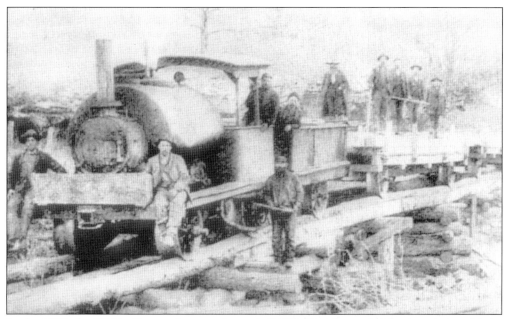

In the 1889, the Webbville stop became the end of EK's 36-mile track. The area, being rich in lumber, drew the railway. To transport lumber out of the woods to the station at Webbville, a tank engine was used over a pole track line. Henry Fisher and his men cut and installed the line over some five miles of logs back in 1890.

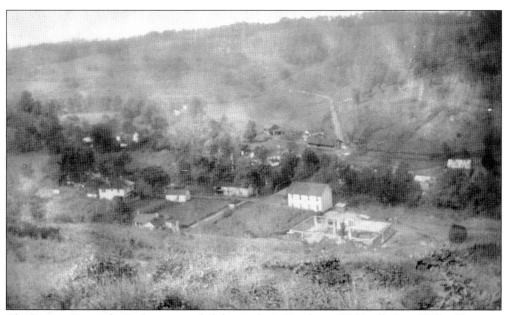

The Eastern Kentucky Railway extended the tracks 1.77 miles to Webbville from Willard because of the abundant lumber coming to Webbville from throughout western parts of Lawrence County. In this photograph of Webbville taken around 1915, the station, Redman Lodge, and the Duncan residence can clearly be pointed out.

Webbville depot was built in 1890, a year after the tracks reached the end of the Eastern Kentucky Railway line. Pictured during some flooding in 1937 is the depot, just four years after Queen dropped off and picked up passengers during her last trip on the Eastern Kentucky Southern Railway tracks.

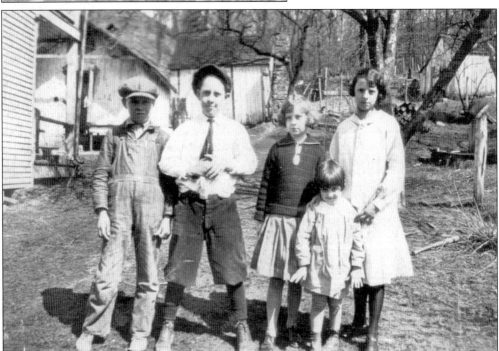

Pictured around 1927 are some of the youngsters belonging to Eastern Kentucky Railway employees in Webbville. Some lived in other towns but would take the train to a different station for a visit with other children along the rail line. When the line was discontinued to the north in 1926 and to the south in 1933, it affected more than just adults.

This toddler is pictured about 1933 with much of the Eastern Kentucky Railway yards of Webbville in the background. Note the two boxcars just behind his head. Much of the scrap left behind at the time of abandonment eventually fell into the responsibility of property owners.

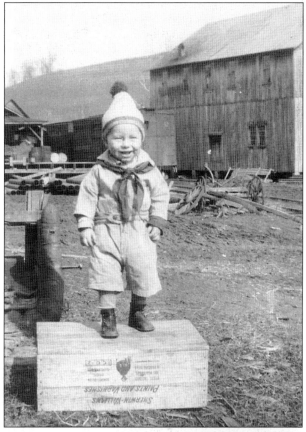

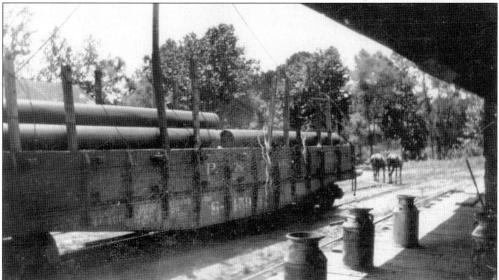

Pictured in the mid-1920s is the Webbville depot with several milk containers sitting as though waiting to be loaded onto an Eastern Kentucky Railway car. Notice the mules to the right that were used to help load the pipe with a pulley-and-cable system, which required only a couple of workers and the mule.

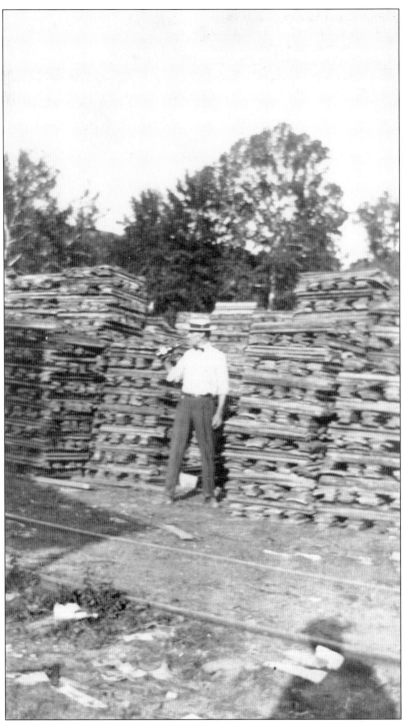

Webbville station agent Fred Duncan enjoys a soda in the Eastern Kentucky Railway store yard in Webbville around 1915. The stacks of wood were made ready for shipment to tool manufacturers in the north. Webbville had a large store yard that housed these bundles of wood and stacks of gas drilling pipe.

Shown is Fred Duncan's Eastern Kentucky Railway pay slip for a total of 130 hours worked. The pay for that time was comparable to other railroads of the day. Duncan averaged around 35¢ per hour. It is not know whether he had a choice of script or cash money.

EASTERN KENTUCKY RY. CO.

Nov. 15, 1928

Fred Duncan

130 Hrs. $45.00

The Webbville store yard appears to be filled with items ready to go. Fred Duncan is shown in this 1918 photograph standing on a spool of cable, as an unidentified young man poses behind him. Fred Duncan grew up near the Eastern Kentucky Railway line in Willard and always wanted to work for the railway.

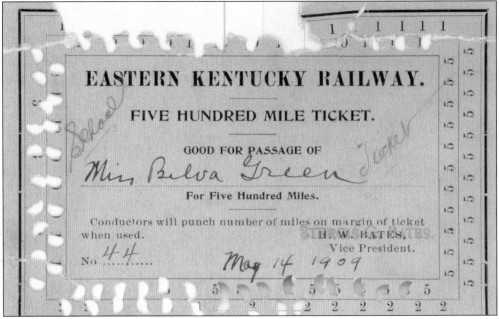

EASTERN KENTUCKY RAILWAY.

FIVE HUNDRED MILE TICKET.

GOOD FOR PASSAGE OF

Miss Belva Green

For Five Hundred Miles.

Conductors will punch number of miles on margin of ticket when used.

H. W. BATES,
Vice President.

No 44

May 14 1909

Belva Green used this 500-mile Eastern Kentucky Railway ticket to attend school every day. She would board the coach early at Webbville and make the daily trip to and from the Grayson Graded School. This included the usual stops of Bellstrace, Willard, Butler, Reedville, Hitchins, and Vincent. She was a student of the school in the early 1900s.

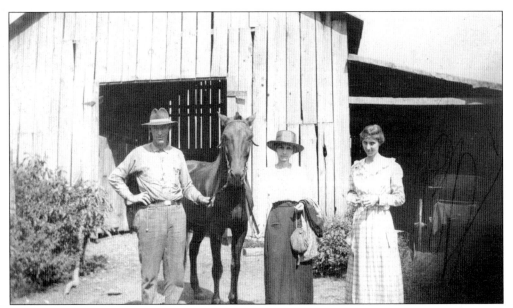

Webbville was a small thriving community in 1900. The lumber business had brought with it money for better selections at stores. The Eastern Kentucky Railway owned the depot, storehouse, and store yard. Pictured about 1915 is Belva Green to the right at the Webbville livery stables.

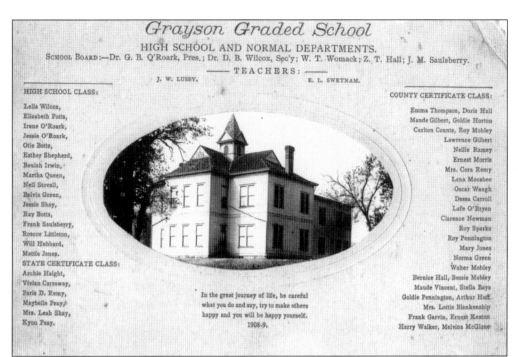

Grayson Graded School

HIGH SCHOOL AND NORMAL DEPARTMENTS.

School Board:—Dr. G. B. O'Roark, Pres.; Dr. D. B. Wilcox, Sec'y; W. T. Womack; Z. T. Hall; J. M. Saulsberry.

—— TEACHERS: ——

J. W. LUSBY, E. L. SWETNAM.

HIGH SCHOOL CLASS:

Lelia Wilcox,
Elizabeth Potts,
Irene O'Roark,
Jessie O'Roark,
Otie Botts,
Esther Shepherd,
Beulah Irwin,
Martha Queen,
Nell Stovall,
Belvia Green,
Jessie Shay,
Ray Botts,
Frank Saulsberry,
Roscoe Littleton,
Will Hubbard,
Mattie Jones.

STATE CERTIFICATE CLASS:

Archie Haight,
Vivian Carnaway,
Paris D. Remy,
Maybelle Peay,
Mrs. Leah Shay,
Kyon Peay.

In the great journey of life, be careful
what you do and say, try to make others
happy and you will be happy yourself.
1908-9.

COUNTY CERTIFICATE CLASS:

Emma Thompson, Doris Hall
Maude Gilbert, Goldie Horton
Carlton Counts, Roy Mobley
Lawrence Gilbert
Nellie Ramey
Ernest Morris
Mrs. Cora Remy
Lena Mocabee
Oscar Waugh
Dessa Carroll
Lafe O'Bryan
Clarence Newman
Roy Sparks
Roy Pennington
Mary Jones
Norma Green
Walter Mobley
Bernice Hall, Bessie Mobley
Maude Vincent, Stella Bays
Goldie Pennington, Arthur Huff
Mrs. Lottie Blankenship
Frank Garvin, Ernest Keaton
Harry Walker, Melvina McGlone

A Grayson Graded School graduation program complete with a photograph of the school is shown from 1909. Belva Green of Webbville put her 500-mile Eastern Kentucky Railway ticket to good use and graduated high school. Helen Dunkle said that Belva, her mother, valued her education so highly that she never thought twice about traveling along the railway so much.

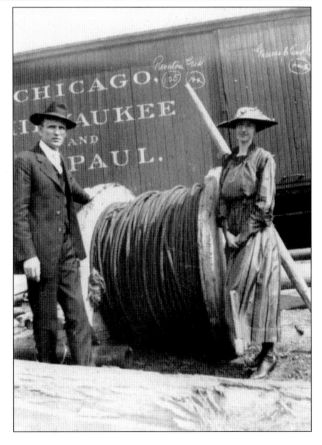

Fred Duncan and his wife, Belva Green Duncan, pose for this photograph at the Webbville rail yards back in 1918. Notice the freight car from Chicago, Milwaukee, and St. Paul in the background. Fred began working for the Eastern Kentucky Railway at a young age as an engine lookout or guard.

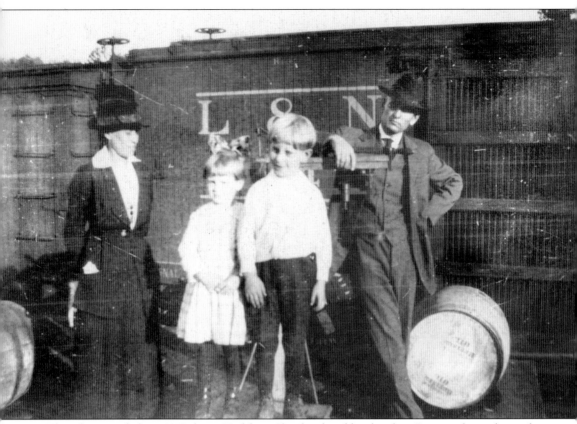

This photograph from 1917 shows Kathleen Shepherd and her brother, Ray, on the scales at the Webbville depot. Fred Duncan and Nell Duncan look on as Louisville and Nashville boxcars are parked behind them waiting to be loaded or unloaded for their long journey back to Riverton, Lexington, or Ashland.

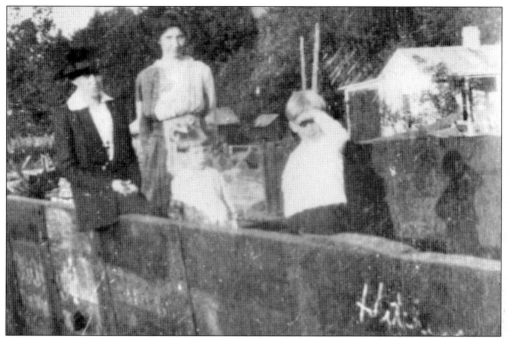

Nell Duncan, Belva Green, Ray Shepherd, and Kathleen Shepherd are pictured from left to right in an abandoned Eastern Kentucky Railway railcar in Webbville in 1917. Note the word "Hitchins" on the side of the boxcar. This could have been used in the Hitchins area as a coal car or storage car.

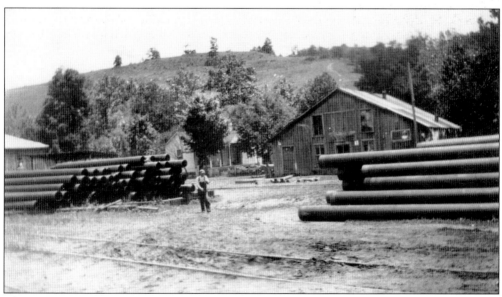

The Webbville store yard is pictured with pipe ready to go to Blaine to be installed in gas wells. In this early-1920s photograph, the Webbville store can clearly be seen in the back. The store has changed names over the years but continued to be a store for many decades after this photograph was taken.

It was from a rafter on an Eastern Kentucky Railway bridge like this one that the Porter hanging took place near Willard in 1892. Fred Duncan was a witness to the hanging at the age of 12. Pictured are Duncan and family walking along the rail line sometime around 1918.

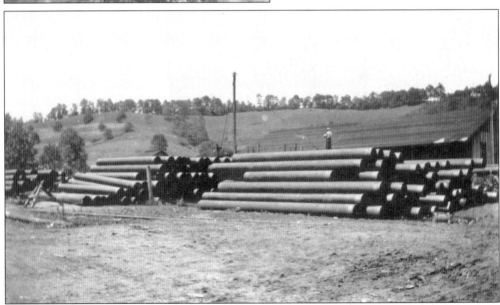

Shown in the early 1920s is the Webbville station, where iron pipe was stored to be used for gas drilling locally and throughout Lawrence and Carter County. Several features can be picked out from these photographs. Notice the depot in this view, and someone is walking around inspecting the amount of pipe in storage.

Shown in 1926 is the Webbville version of the school bus, with four powerful legs. The children at this time attended school quite a distance south, requiring a mule on snowy days. Eventually the old Redman Lodge above the church and even the Webbville depot were used as schools for the children of Webbville.

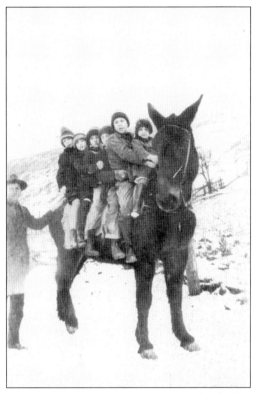

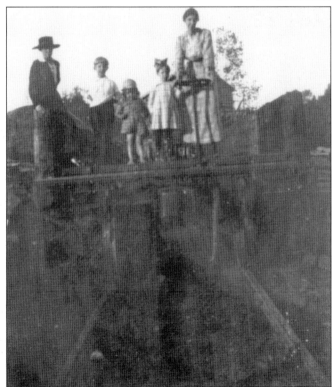

Pictured from left to right, Nell Duncan, Ray Shepherd, an unknown young girl, Kathleen Shepherd, and Belva Green play as if they are slowing the Eastern Kentucky Railway flatcar using its brake. These photographs were taken about 1917 by Fred Duncan, who was the longtime Webbville station agent for the railway and went on to work for the C&O.

This 1920s photograph of the Webbville station clearly demonstrates how iron pipe for oil wells was loaded onto railcars. Notice the pulley system: cables lift part of the pipe, load it into place, and slack down on the pole to secure another stop, thus loading the complete iron pipe on the railcar. This could be done with a mule and a man.

A group of young adults poses for this 1920 photograph in front of a stockpile of wood that will be used for Eastern Kentucky Railway cross ties, as a boy sits atop them. The Webbville store is seen in the background. Many people during this time met near stores to talk and trade news from the day's activities.

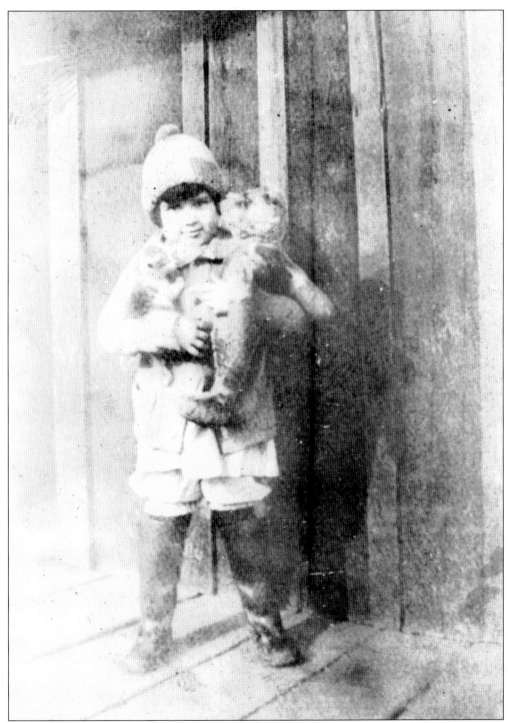

Helen Duncan and her teddy bear make their rounds of the muddy Webbville station grounds in the middle 1920s. Fred bought Helen the bear when she was around three years old in 1925. The Eastern Kentucky yards flooded during long periods of rain, but floods never posed a threat to the railway or the depot.

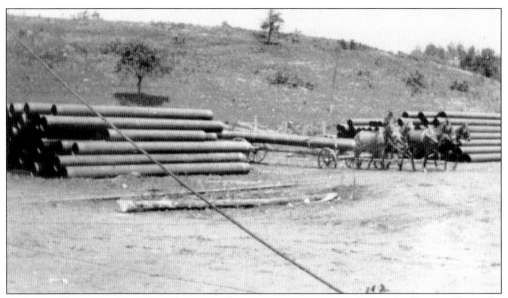

A man and his six mules pull one large metal pipe via a wagon to its place in the Eastern Kentucky Railway store yard at Webbville. With the cable-and-pulley system in place, just a man or two and a mule could load pipes on railcars to be shipped out to gas wells.

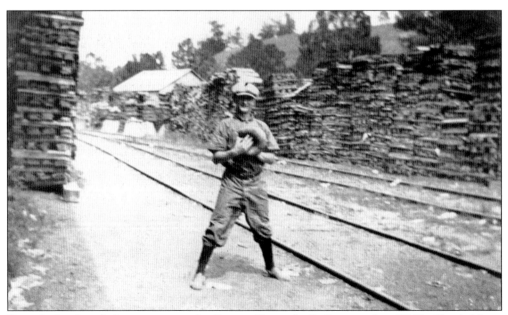

Even the hard work that went on in the Eastern Kentucky Railway yards at Webbville could not take baseball from a boy, Watson Rucker. Shown in 1910, Rucker plays baseball on the tracks, as potential baseball bats masquerade as stacks of lumber waiting to be shipped out.

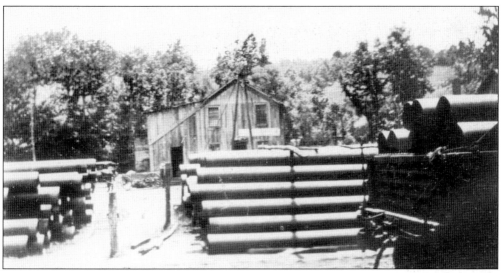

The old Webbville store in the early 1920s is partially obscured by stacks of iron pipe. Notice the car to the right loaded with pipe and ready to make its way toward Grayson for area gas wells. Gas wells have been a small source of income for a few Eastern Kentucky families since the early 1920s.

☆WEBBVILLE HOTEL,☆

DUE EAST OF DEPOT,

W. L. GREEN, PROPRIETOR.

RATES, $1. PER DAY.

The Patronage of the Traveling Public
Solieited.

WEBBVILLE, ∴ KENTUCKY.

Webbville had a hotel since the Eastern Kentucky Railway came to this area in the 1880s. The hotel was owned and operated by W. L. Green for a number of years. Quite a few traveling along the railway between Webbville and Riverton took advantage of his dollar-a-day charge.

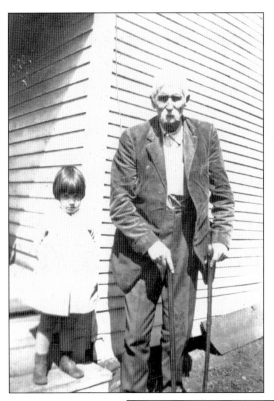

Pictured in the mid-1920s are Helen Duncan and Webbville hotel owner W. L. Green. Green was 6 feet, 6 inches tall, very tall for a man during this time. If asked how tall he was, he always stated he was 5 feet, 18 inches tall. Green used two canes with which to walk, as seen in the photograph. Helen has both canes today.

Helen Duncan Dunkle and Kathleen Shepherd Chenault were instrumental in getting a historical marker put up at the site of the Eastern Kentucky Railway yards several years back through the Eastern Kentucky Railway Historical Society. The marker is located near where the gas pipes were stored, across the street from the old store in Webbville.

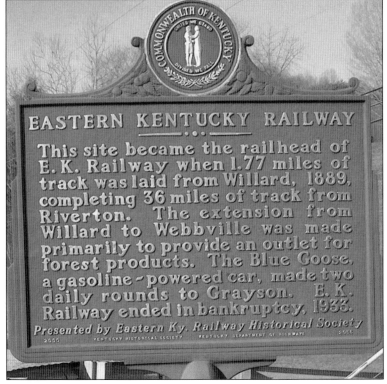

COMMONWEALTH OF KENTUCKY

EASTERN KENTUCKY RAILWAY

This site became the railhead of E. K. Railway when 1.77 miles of track was laid from Willard, 1889, completing 36 miles of track from Riverton. The extension from Willard to Webbville was made primarily to provide an outlet for forest products. The Blue Goose, a gasoline-powered car, made two daily rounds to Grayson. E. K. Railway ended in bankruptcy, 1933.

Presented by Eastern Ky. Railway Historical Society

Four

The Eastern Kentucky Southern Railway

The very early 1920s proved to be somewhat profitable for the Eastern Kentucky Railway. This was due to the increase in demand for coal brought on by the First World War and worker strikes going on throughout the country. Another factor was the increase in shipments of road-building materials for highways then being constructed that would soon compete with the railroad for transportation dollars. Since the Eastern Kentucky Railway began operation in 1870, it had acquired a deficit of more than $900,000 due to the losses of the iron furnaces, poor coal quality, and overlogging that had gone on until this time.

In 1925, because of these losses, a court directed the railroad to file an application for abandonment of the entire Eastern Kentucky Railway; this was submitted June 1, 1926. The application mentioned the economic woes of the past as well as the bleak outlook for earning potential because of the automobile.

At this time, protests regarding the complete abandonment arose from citizens from Grayson to Webbville who used the railway for travel. The commission agreed with these citizens and allowed the southern end of the Eastern Kentucky Railway to operate, transporting passengers and mail only.

As the rail line in Carter and Lawrence Counties grew older and its condition deteriorated, a decision was made not to run the large locomotives. For a few months in 1927, a motorized gasoline car was used for transportation. This proved impractical, and it was replaced by the car and trailer M1 and M2, commonly referred to as the "Blue Goose." The Blue Goose ran a regular route between Grayson and Webbville until 1928. At this time, the southern end of the Eastern Kentucky Railway was purchased and renamed the Eastern Kentucky Southern Railway. In 1929, the new company purchased the larger, bus-like vehicle No. 215 and gave it the name "Queen," in honor of a Mertle Queen, to run the southern route. Why it was named after Mertle Queen remains a mystery. The vehicle was used for several years and required very little maintenance.

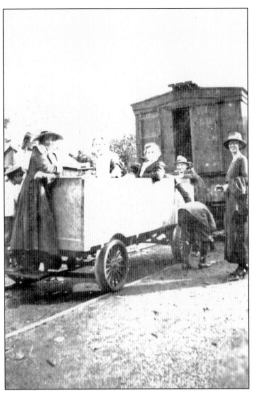

For a few months during 1927, the gasoline motorcar pictured was used as an experimental means of transportation between Grayson and Webbville. Locomotive and passenger cars ran on a limited schedule prior to the motorcar and were abandoned because of the declining condition of the 13.5 miles of track.

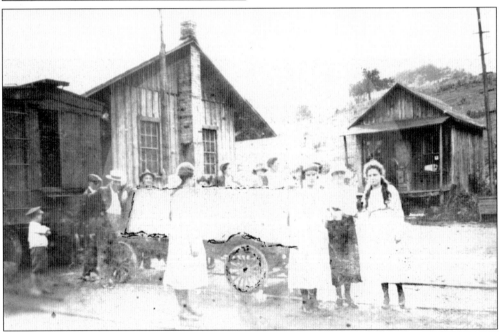

Pictured is the gasoline motorcar with pen markings from an earlier time outlining the body and wheels. The motorcar had a Ford engine and was made entirely at the Eastern Kentucky Railway shops in Grayson. When the car was taken out of use, it sat in the Webbville yards for several years and eventually was scrapped.

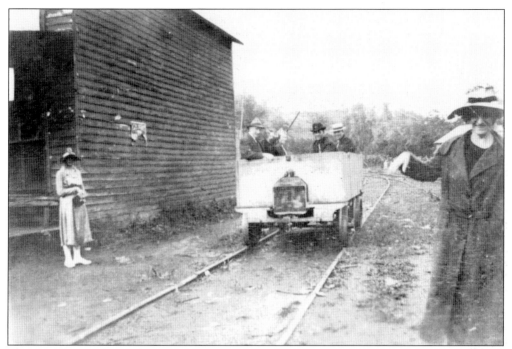

Shown in 1927 is the gasoline motorcar that proved to be more of a novelty than a serious method of transportation. The car was open and therefore good only on clear, warm days, and no more than seven people could ride comfortably at one time. It has been commented on as being very loud and rickety.

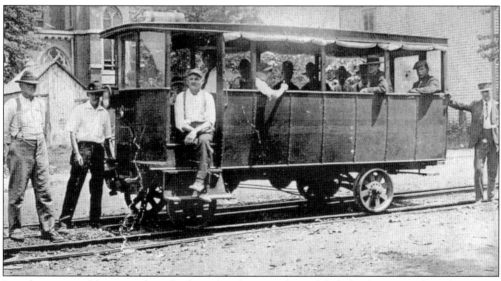

In at least one publication, the vehicle in the photograph was labeled as being another Blue Goose in Grayson. There are no records of a vehicle such as this operating along the Eastern Kentucky Railway line. Many have come forward to state that the background is not a recognizable location in Grayson. This photograph from the 1920s was most likely taken in Ashland or Huntington.

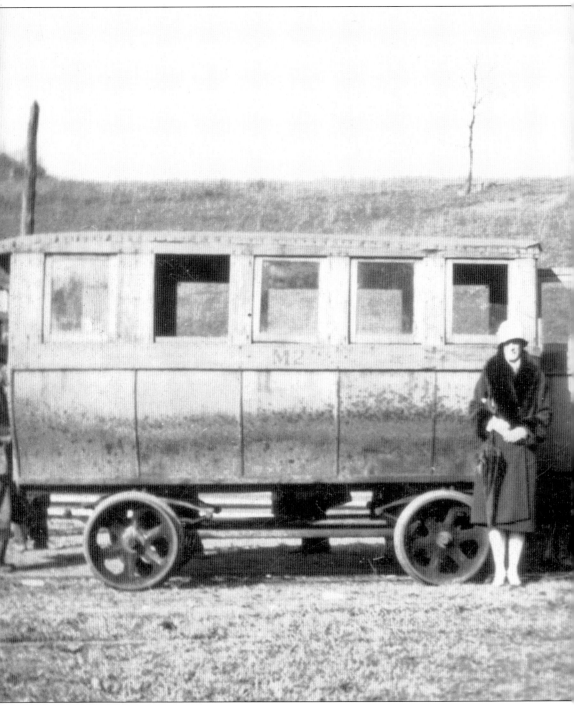

Photographed in Webbville in 1929 are two unidentified women standing with the trailer car M2 and the motorcar M1, known collectively as the Blue Goose. The vehicles were obtained after the abandonment of the northern end of the Eastern Kentucky Railway. This would provide much-needed passenger travel over the southern end after citizens of Grayson, Hitchins, Willard, and Webbville protested the plans to abandon the southern end. Many students had used the

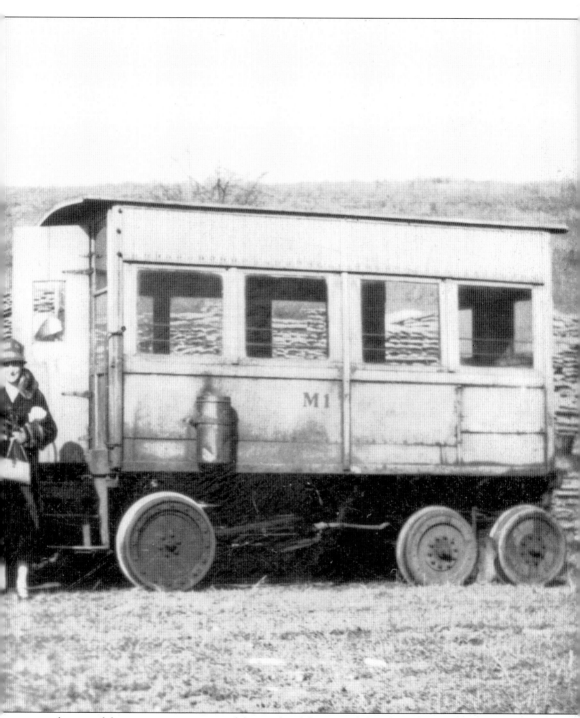

southern end for transportation to and from school for several decades. The cars were said to be cramped and noisy and the ride bouncy, but there were never any reports of derailment or injuries attributed to the Blue Goose. Except for Sunday, the Blue Goose made two round trips, leaving Grayson at 8:30 a.m. and 3:00 p.m. and leaving Webbville at 9:30 a.m. and 4:02 p.m.

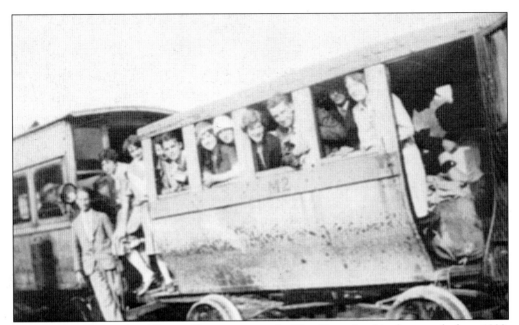

Students from the nearby college in Grayson pose in the Blue Goose for this photograph about 1928. The close room is evident, with the baggage piling up and blocking the back exit of M2. Nonetheless the young people are excited about going on a trip along the Eastern Kentucky Railway.

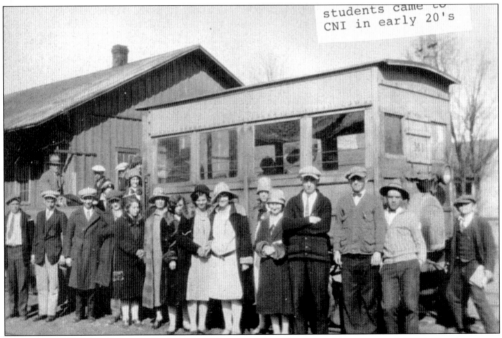

students came to CNI in early 20's

A group of students pose with the Blue Goose at the Grayson depot around 1928. By this time, the students could take the Blue Goose to Hitchins and switch railroads for a day trip to Ashland or even Huntington. Many students recall doing that on Saturdays as a way to see the area.

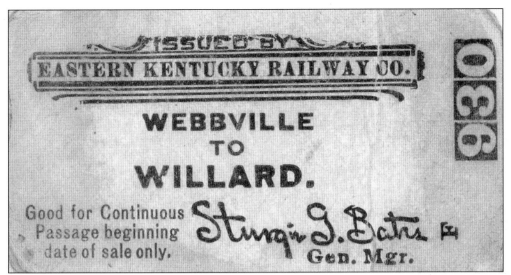

The Eastern Kentucky Railway used many different styles and colors of tickets. Pictured is one of the last tickets used by the railway before abandonment in the late 1920s. This ticket was also the smallest, at 1 inch by 2.5 inches, and was used to ride the Blue Goose between Webbville and Willard.

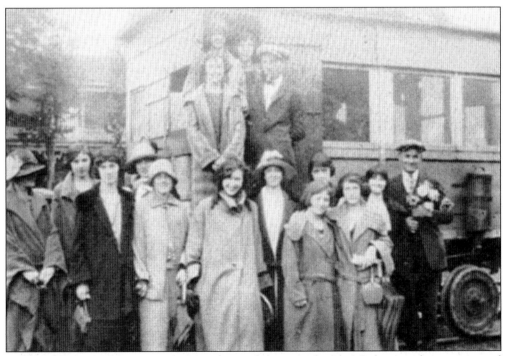

Students in Grayson pose in front of M1 around the time the Blue Goose was decommissioned by the Eastern Kentucky Southern Railway. The young people seem to sense the importance of the Blue Goose to Grayson and eastern Kentucky history. Some who rode the Blue Goose say it was a light green color, while others state it was light blue.

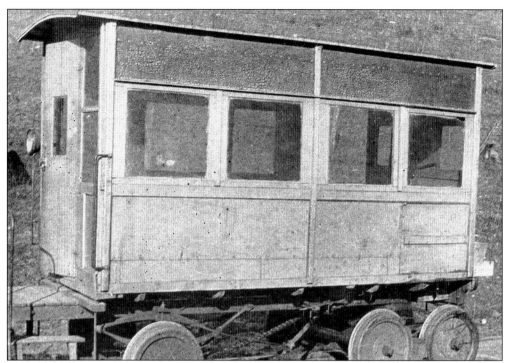

The engine used in the M1 or Blue Goose was partially built and maintained by the Eastern Kentucky Railway shops in Grayson. The engine was said to be out of a Ford "Tin Lizzy." It was said that riding the Blue Goose was painful to the ears, thus many people would try to get a seat on the quieter M2 trailer.

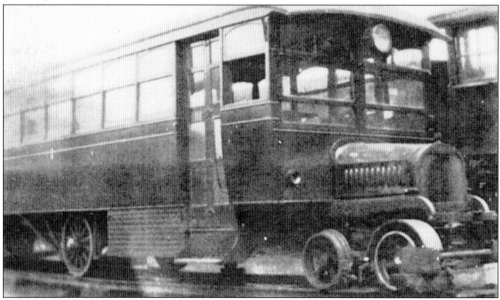

Built in June 1921, this Mack gasoline-powered railcar No. 70005 was purchased by the Sewell Valley Rail Line, where it was used for public transportation for eight years. Pictured is the 70005 parked in 1928, still under the ownership of Sewell Valley Rail Line and with several other vehicles keeping it company.

This undated view shows No. 215, "Queen," rusting away with several Eastern Kentucky Southern Railway cars in the background. Note the condition of the railroad ties and the dirt buildup on Queen's windshield. This photograph was most likely taken around 1934, a year after the Eastern Kentucky Southern Railway was abandoned.

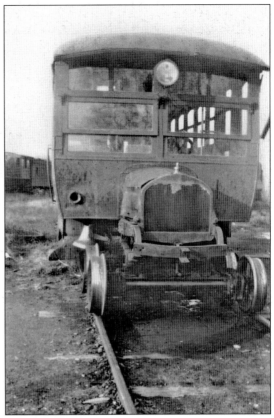

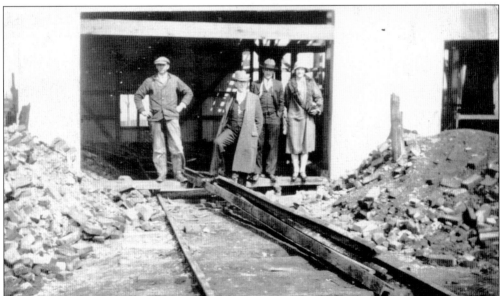

John Kitchen, second from the left, and several others visit one of the Eastern Kentucky Southern Railway shops around 1931. The debris on each side in the photograph could possibly be the remnants of the larger original shop, which burned not long before this picture was taken. Kitchen worked for the Eastern Kentucky Railway for a number of years.

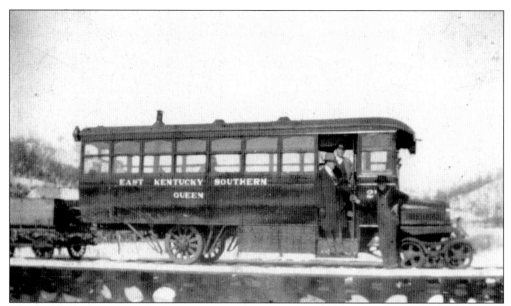

The Eastern Kentucky Railway's Queen poses in this photograph around 1931 near Vincent. John Kitchen stands in the doorway discussing something with the operator. No. 215 was said to be much quieter than the Blue Goose, and the ride resembled a school bus more than a train.

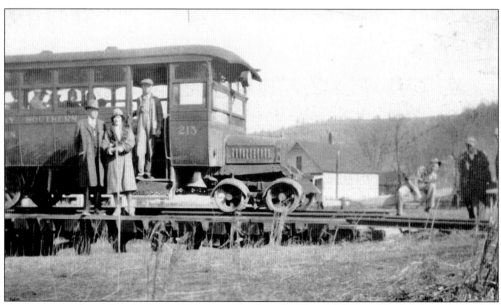

Queen stopped near Reedville in 1931. John Kitchen (left) and Ollie Queen (center) stand with the operator outside this Eastern Kentucky Southern Railway–owned vehicle. Eventually the cost of maintaining the tracks was too much for this young company to keep up with, and the southern route was abandoned.

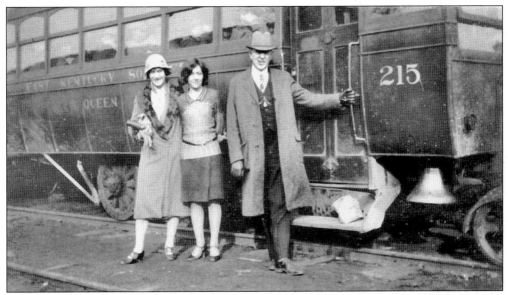

This is a close-up of Ollie Queen (left), an unidentified young woman (center), and John Kitchen in 1931 with No. 215 behind them. Notice the bell to the right of the doorstep. Through Queen was in operation for only a few years, old residents today remember the vehicle with a great sense of pride.

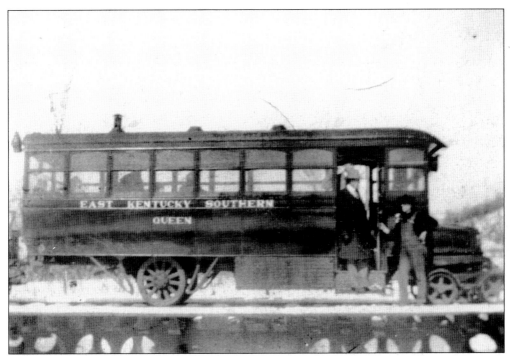

No. 215 ran a couple of times each day between Grayson, Willard, and Webbville. The Eastern Kentucky Southern Railway allowed the operator to stop anywhere along the tracks to pick up and drop off passengers. For winter travel, a small, wood-burning stove was installed near the rear of Queen.

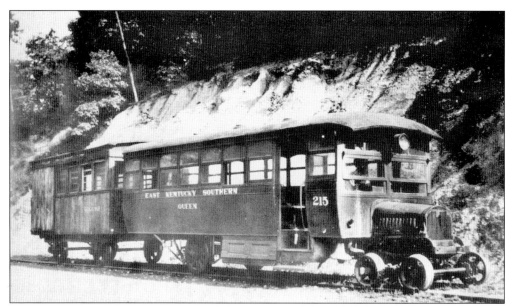

This is the most popular photograph of the Eastern Kentucky Southern Railway's No. 215, or Queen. Normally wherever No. 215 went, the baggage car followed. The baggage car was built at the shops in Grayson in 1930. Queen was the ex-Sewell Valley Rail Line No. 29 and was purchased secondhand in 1929.

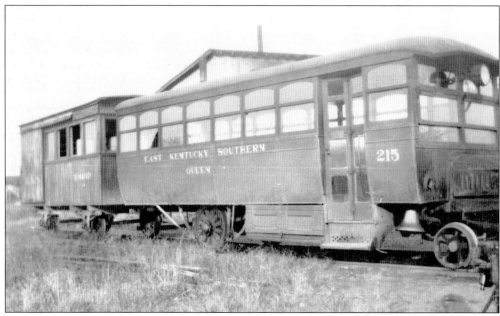

This 1933 photograph shows No. 215 in the Eastern Kentucky Southern Railway Grayson depot yard just after abandonment. Notice the broken window on this side of Queen and the dirt buildup. The baggage car is missing some windows. Queen was sold for scrap and dismantled not long after this photograph was taken.

Five

A LAST RIDE

The Eastern Kentucky Southern Railway had an income for its first three years of $1,089, $1,427, and $110. It was estimated in 1932 that it would cost the railway a total of $10,000 to update the rail line in order to maintain safe transportation. Adding to this was the decrease in freight traffic originating on the line between the years 1929 through 1932, coupled with the Great Depression. The Eastern Kentucky Southern Railway filed an application for abandonment on December 12, 1932, and exactly one week later, permission was given to scrap the 13.41 miles of main track and 3.6 miles of siding. Service on the line was terminated near the end of January 1933, and the work of dismantling the southern line began shortly thereafter.

Since the abandonment of the railway in the 1920s and 1930s, several published articles have appeared in local newspapers throughout the years. Jesse Stuart related his Eastern Kentucky Railway memories in the August 1937 issue of *Esquire* magazine and in the 1966 release of his book *A Ride with Huey the Engineer.*

The Eastern Kentucky Railway left in its abandoned path tangible relics that can be picked out over 70 years after the last ride along the meanderings of the Little Sandy River to Vincent and the migrations of Little Fork and tributaries the rest of the way to Webbville. A bridge, a building, or perhaps a lock will surface and cause someone to ask, "What was the Eastern Kentucky Railway?" The answer will most likely come from a grandfather, a grandmother, or perhaps another older person who lives along the old route, now the EK Highway in parts of Greenup, Carter, and Lawrence Counties in eastern Kentucky.

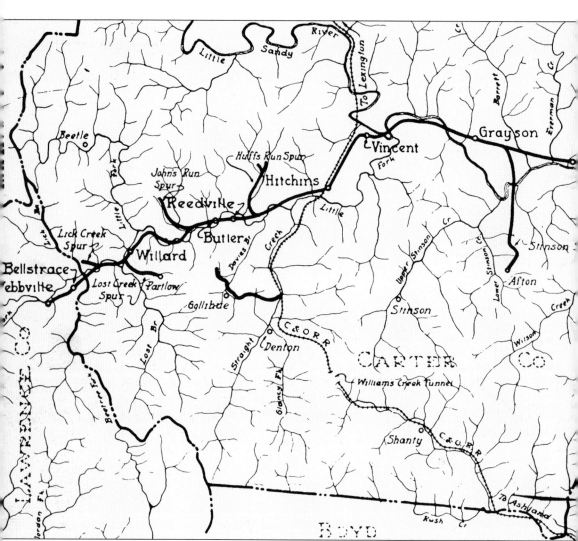

This Eastern Kentucky Railway map shows the complete route of the main 36-mile track as well as all the stops in Greenup, Carter, and Lawrence Counties in Kentucky. Also shown are all water crossings along the rail line, as well as the Turkey Lick Spur, the Coal Creek Spur, the Kane Creek Spur, the Stinson Spur, Huffs Run Spur, John's Run Spur, Lost Creek Spur, and Lick Creek Spur. The two crossings of the C&O Railroad in Riverton and Hitchins are clearly

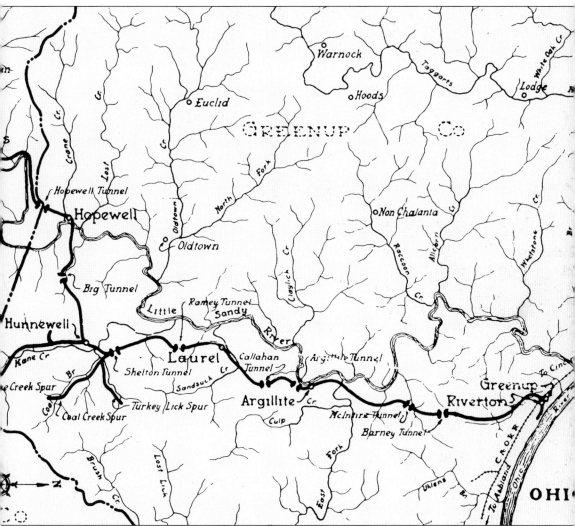

marked, as well as the eight tunnels: Barney, McIntire, Argillite, Callahan, Ramey, Shelton, Big Tunnel, and Hopewell. Several old maps have the Eastern Kentucky Railway line as well as the location of area furnaces, mills, and mines, along with various waterways and towns. This map dates from 1900.

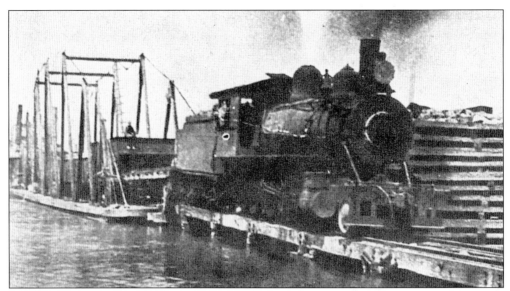

Until the 1880s, the Eastern Kentucky Railway had to rely on transporting its cars and materials via barge across the Ohio River. In the 1880s, two railroads crossed the Eastern Kentucky Railway at Riverton and Hitchins. Many of the items shipped via the Ohio River made their way through this dock in Coal Grove, Ohio.

The original plan of Thayer and Hunnewell was to bridge the Ohio River at Riverton, thus enabling them to transport eastern Kentucky natural resources to the mills along the Great Lakes region. This plan never came about for the railway; however, the C&O Railroad did bridge the Ohio River in Greenup County across from Portsmouth, Ohio.

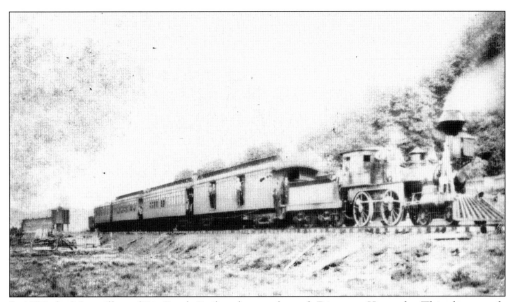

In 1889, the Maysville and Big Sandy Railroad came through Riverton, Kentucky. This photograph is an early picture of an engine from this railroad in Greenup County. Eventually the C&O Railroad would purchase this section, which would bring more loads of coal and material across the Eastern Kentucky Railway from Hitchins.

Collis P. Huntington invested much of his wealth in the spreading of his C&O Railroad empire across the Ohio Valley. He knew what to do and when to do it, thus buying out and running out a number of small railroads in the area. There was no question about it—Huntington knew more about the railroad business than any man.

The C&O car shops in Russell and Raceland, Kentucky, built coal cars very quickly. By the time this photograph was taken in the late 1930s, the Eastern Kentucky Railway was just a memory. Several former Eastern Kentucky Railway employees began to work for the more stable C&O Railroad, where they retired.

Shown are six C&O Railroad workers assigned to track upkeep near Riverton and the Eastern Kentucky Railway section in the 1920s. Several of these men may have begun working for the Eastern Kentucky Railway and transferred to C&O shortly before abandonment of the northern section of track.

The Eastern Kentucky Railway may have been a larger railroad if it had gone both east and south. Pictured are the enormous C&O Railroad yards in Russell and Raceland, Kentucky. This was the center of railroad activity south of the Ohio River for many years. This is the type of success that Thayer and Hunnewell could only dream of.

Shown in this postcard is the new C&O station built in the 1920s in Ashland, Kentucky. This station is like a diamond to a common rock when compared with anything the Eastern Kentucky Railway had previously built. This well illustrates the success achieved by the C&O Railroad.

THE ASHLAND NATIONAL BANK, ASHLAND, KY.

In the 1920s, the railroad, steel industry, and businesses in general grew throughout Ashland and along the banks of the Ohio River. Better-quality coal and iron were shipped via the C&O Railroad and barges to this point, where the mills produced quality products. The early 1920s brought prosperity to this river city bordering Ohio and West Virginia. To handle the influx of businesses, a larger bank needed to be built. The Ashland Bank built this structure to handle the growth taking place around the city. Notice the cars and streetcars in this view of the bank. Ashland was a thriving town partly because of the railroad industry. Today this beautiful building still stands and is the first thing people notice when visiting Ashland for the first time. Many of the businesses from the 1920s are gone, but the building still houses a bank.

Entrance to Clyffeside Park,
near Huntington, W. Va.

Cliffside Park was a popular park attraction in the late 1800s and early 1900s. A person from Hunnewell could take the Eastern Kentucky Railway to Riverton, switch to the C&O, and ride to the east side of Ashland, where this park was located. This postcard from the early 1900s shows the park's entrance.

The Coal Grove Bridge and railcars make up the Ohio River bank in Ashland, Kentucky, in the view from around 1930. Today the bridge and just a fraction of the railroad in that vicinity of Ashland continue on. Ashland became the largest city in eastern Kentucky in part because of the railroad and steel industry.

In this early postcard of western Greenup County, three tracks are clearly seen running between Riverton and the Portsmouth Bridge. If these resources had been available to the Eastern Kentucky Railway, it could have exploited the natural resources of eastern Kentucky much sooner than eventually came about.

ASHLAND PLANT, AMERICAN ROLLING MILLS, ASHLAND, KY.

The mills that operated in Ashland, Kentucky, were much larger than any furnace in Greenup, Carter, or Lawrence Counties. Railroads operated seven days a week transporting their goods to businesses in the Great Lakes region of the United States. The mill pictured could produce 1,000 times as much in a week as all the iron furnaces owned by the Eastern Kentucky Railway.

Several other railroads like the Eastern Kentucky Railway owned their own mills. Pictured is the R. C. Poage Milling Company, owned by the Ashland Coal and Iron Railway Company in Ashland, Kentucky. Floods such as the one in the photograph damaged many companies along the Ohio River, as they had done to the Eastern Kentucky Railway.

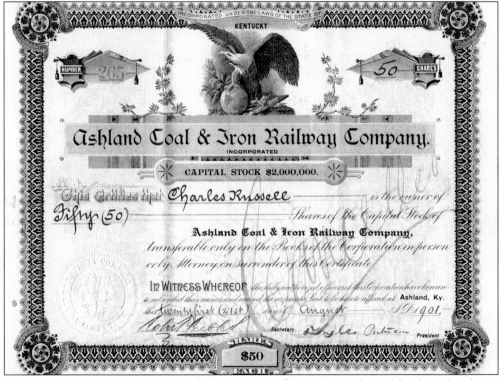

Pictured is a railroad stock for a total of 50 shares at $50 a share. The Ashland Coal and Iron Railway Company offered stocks like this to the public when losses began to occur. Eventually the line between Ashland and Hitchins, as well as a couple of mines, was purchased by the C&O Railroad.

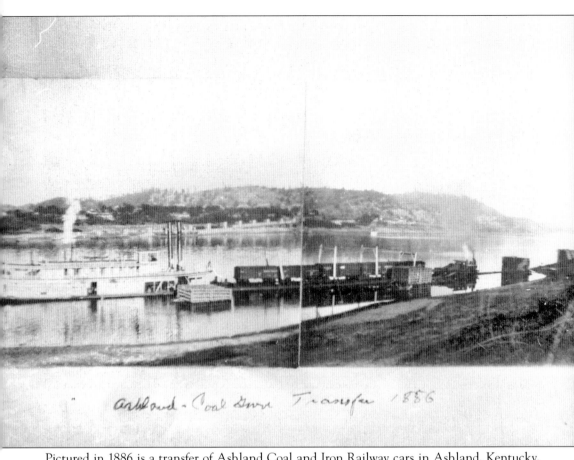

Ashland - Coal Iron Transfer 1886

Pictured in 1886 is a transfer of Ashland Coal and Iron Railway cars in Ashland, Kentucky. Until the early 1900s, cars and material had to be transferred across the Ohio River via barge. In the early 1900s in eastern Kentucky, the Ohio River was bridged near Huntington and near Portsmouth, Ohio.

Like the Eastern Kentucky Railway, the Ashland Coal and Iron (AC&I) Railway owned several coal mines. Shown is the AC&I coal mine near Rush in Carter County, Kentucky. The mine was sold just before the AC&I was bought out by the C&O Railroad and continued to be mined for several years under a different owner.

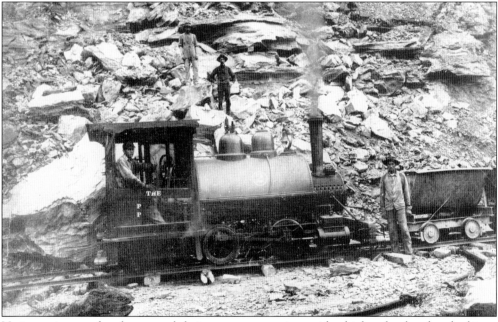

Various mines used and possessed their own steam engines with which to haul and push objects along their tracks. Shown is a slate mine near Fire Brick in Greenup County, Kentucky in the early 1900s. Engines for mines like this were usually purchased secondhand and maintained at the mine.

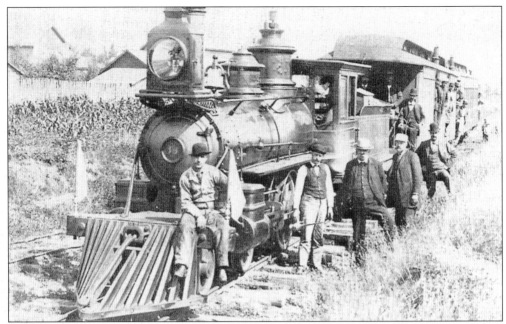

Besides the Eastern Kentucky Railway, the C&O Railroad, and the AC&I, other railroads were operating in eastern Kentucky. Each railroad was competing for the larger industry dollars north of the Ohio River. Pictured is the Kinniconnick and Freestone Railroad about 1891 in Lewis County, Kentucky.

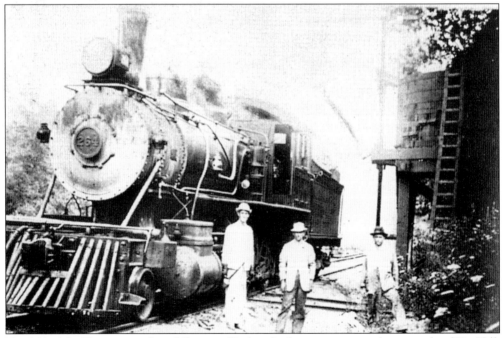

No. 264 of the Kinniconnick and Freeston Railroad takes on water on the east side of Big Hill. This railroad ran between Garrison in Lewis County and Carter in Carter County and was eventually bought out by the C&O Railroad. Unable to make a profit, the C&O abandoned this track around 1940.

Many individuals in eastern Kentucky and across the country abandoned rail travel as automobiles flooded onto the market. Pictured around 1922 is George Spencer of Buffalo Creek, near present-day Greenbo Lake State Resort Park. The automobile allowed individuals to work at jobs many miles from home.

Roads like the one pictured here in the 1930s in Greenup County were one of the major contributing factors that led to the demise of the Eastern Kentucky Railway as well as many other railroads throughout the country. Area road development opened up eastern Kentucky resources to the mills along the Great Lakes and to large cities.

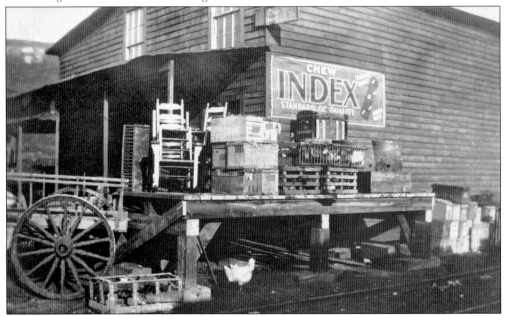

Pictured is a store once believed to be near Webbville or Bellstrace around 1925. No such store has been authenticated along the Eastern Kentucky Railway line. Notice the close proximity of the tracks and the building, giving the impression that this also served as a depot.

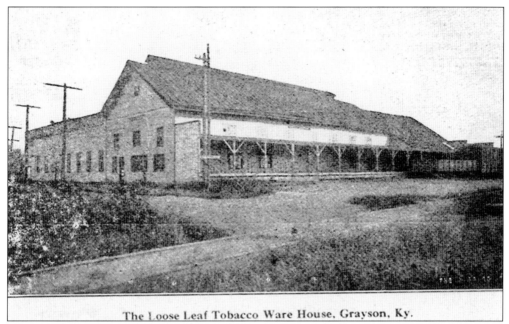

The Loose Leaf Tobacco Ware House, Grayson, Ky.

Photographed in the early 1900s is the Loose Leaf Tobacco Warehouse in Grayson, Kentucky, where many farmers from within Carter County and surrounding counties brought their tobacco at the end of the year. Eventually the tobacco warehouses began to move either south or west to towns such as Maysville and Morehead.

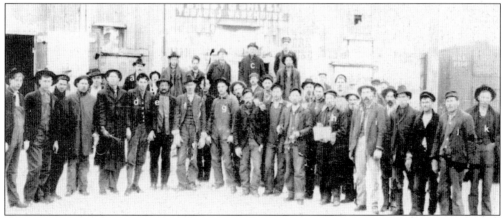

Shown in this group photograph from the early 1900s are tobacco warehousemen with railcars waiting to be loaded in the background. The Eastern Kentucky Railway had several spurs that went from the main track to places of business like this tobacco warehouse in Grayson, Kentucky. The tobacco could be loaded and easily shipped anywhere.

103

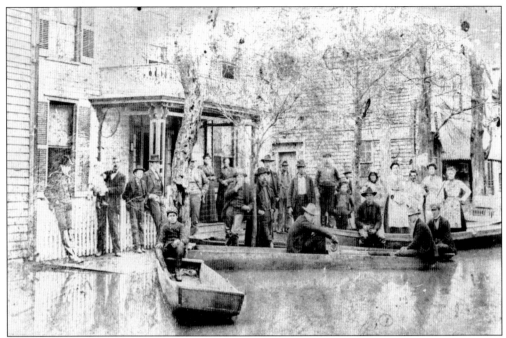

Flooding caused a great deal of damage to businesses like the Eastern Kentucky Railway. In 1899, flooding along the Little Sandy River Valley washed out several miles of tracks, buildings, and bridges. Pictured is the flood of 1913 near Riverton, which caused much damage to the C&O Railroad as well.

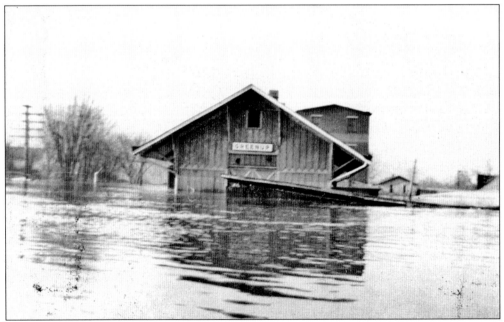

Riverton and Greenup were much more prone to flooding that any other stops along the Eastern Kentucky Railway route. The Ohio River was a fear for the railway staff in Riverton whenever the rains went on for more than several days. Many not only lost their incomes for a limited amount of time, but some also lost their homes.

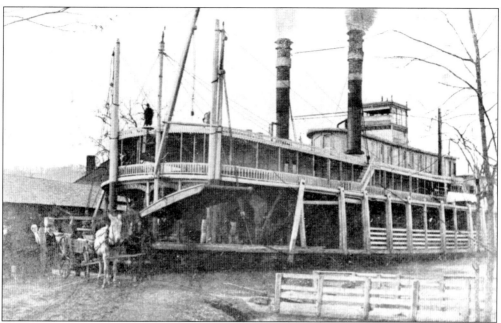

Floods also claimed businesses that operated by transporting items on the Ohio River. Flooding could block personnel from getting to their boats, and many times the boats would drift away from their docks and end up over the bank after the waters receded. Photographed is a riverboat stuck on the bank near Riverton in 1913.

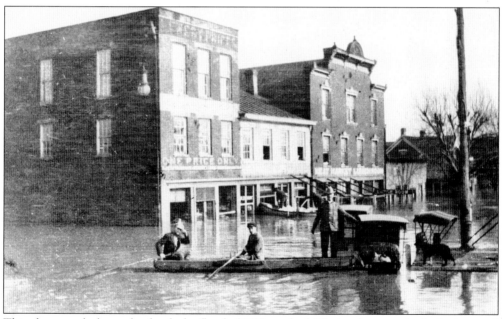

This photograph shows the depth the flood of 1913 reached. Notice the stores in the background with at least 4 feet of water in them, as a merchant salvages what he is able. The buildings in the background still stand today. Floods like this stopped the Eastern Kentucky Railway from running between Argillite and Riverton.

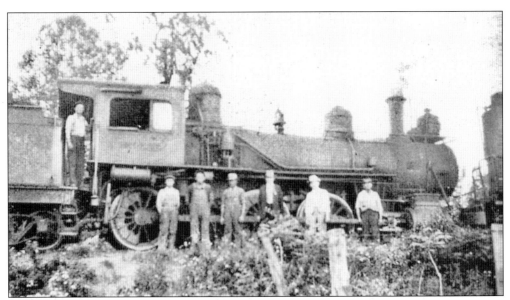

Sometime early in 1926, the Eastern Kentucky Railway made a last trip from Webbville to Riverton. Here is one view of two photographs taken around the same time. It was said that the last locomotive engine to travel the complete route did it on a beautiful Sunday. Though the railway received bands playing and large picnics when coming into a town, nothing but the whistle made noise on the way out.

A young woman poses for a photograph near an Eastern Kentucky Southern Railway bridge near Grayson in 1930 while waiting on No. 215 for a ride into town. This photograph, like several others, was used in newspaper articles throughout the time following abandonment, and at times some of the same photographs appear in articles today.

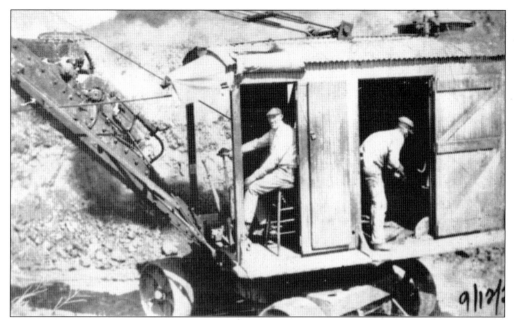

Steam shovels like the one in this image took up the track of the Eastern Kentucky Railway after abandonment. These shovels also were used to turn some of the old rail bed into roads for automobiles. Today much of the old rail bed of the Eastern Kentucky Railway is highway bed running through Carter, Greenup, and Lawrence Counties.

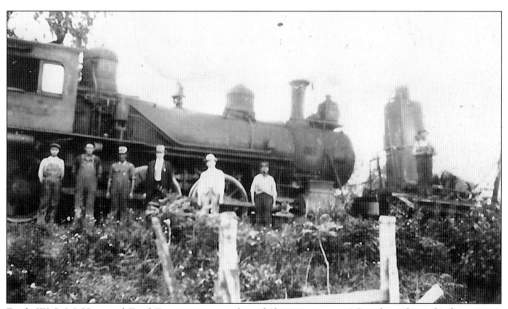

Both W. J. McKee and Fred Duncan remembered that it was on a Sunday when the last steam engine, No. 5, ran the full 36-mile length of the railway in 1926. Pictured are seven people. The first five, from left to right, are known: Ollie Callihan, D. W. McDavid, Hogan Dexter, Col. J. W. Kitchen, and W. E. Porter.

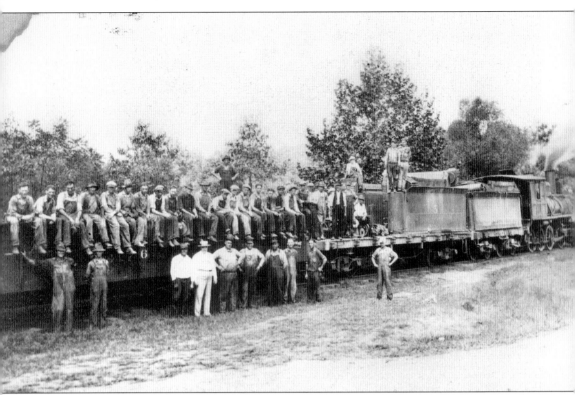

An Eastern Kentucky Railway work crew busy themselves taking up parts of the northern line from Pactolus to Riverton in late 1926. Hopewell had some 713 feet of sidings and spurs to take up, while Hunnewell had a total of 833 feet and Argillite had 887 feet. In addition to the main line, spurs, and sidings, this crew was responsible for taking up the 100-foot-long bridge that crossed East Fork via an iron truss. The tracks in all eight tunnels were taken up, but the spikes and cross ties were left to rot. Everything was sold for less than scrap price. This was about the time much of the rail bed along the line was turned into road for the emerging automobile travel industry. Eastern Kentucky Railway foreman Mr. Callahan is pictured at center dressed in white.

In 1926, several work crews began clearing track along the northern route of the Eastern Kentucky Railway. It took about six months to complete this job and sell off the scrap metal. An Eastern Kentucky Railway work crew poses for the camera near the north entrance of Barney Tunnel. Many of these men would go on to work for the C&O Railroad.

The Eastern Kentucky Railway remained a company for several years after abandonment. The company owned land and assets that did not get sold off until the mid-1930s. The last president of the railway, Sturgis Bates, confirms this in a letter to Fred Duncan in 1938. He states that the railway by this time no longer existed.

EASTERN KENTUCKY RAILWAY COMPANY

Ashland, Ky., June 8, 1938

Mr. Fred Duncan
Augusta, Ky.

Dear Sir:

At the request of Mr. H. F. Irwin I am sending you a copy of your service record signed by me as a former officer of E. K. Ry. as requested of him by your wife recently.

I am signing this as a FORMER officer for the reason that the E. K. Ry. Co. is no longer in existance, having surrendered its charter last December 20.

Hoping that this will be of service to you, for I always like to be of any possible aid to our former employees, I am,

Yours very truly,

Sturgis G. Bates, Receiver

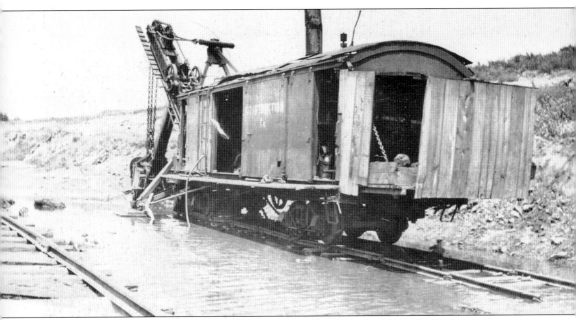

Photographed near the Turkey Lick Spur at Hunnewell, an Eastern Kentucky Railway construction steam shovel sits abandoned and waiting to be sold as scrap. The photograph was likely taken around 1926, as no tracks had been taken up in this area. The Eastern Kentucky Railway owned two shovels during its history.

The Eastern Kentucky Railway Historical Society has more historical markers dedicated to the Eastern Kentucky Railway than are dedicated to any one historical item in the entire state of Kentucky. Shown is the second marker erected along the old railway route at Argillite. The marker is located just off Route 1 going toward the stores in Argillite.

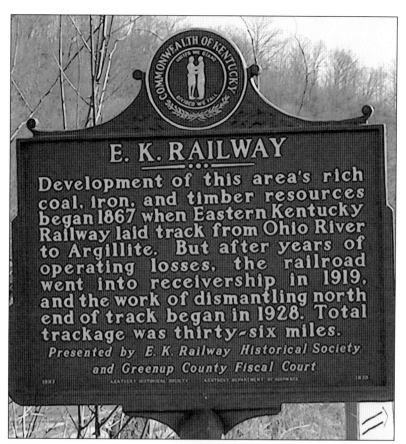

E. K. RAILWAY

Development of this area's rich coal, iron, and timber resources began 1867 when Eastern Kentucky Railway laid track from Ohio River to Argillite. But after years of operating losses, the railroad went into receivership in 1919, and the work of dismantling north end of track began in 1928. Total trackage was thirty-six miles.

Presented by E. K. Railway Historical Society and Greenup County Fiscal Court

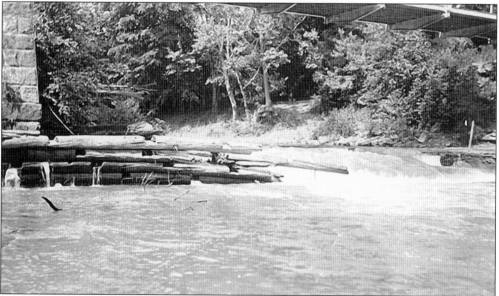

This 1930s photograph shows what remains of the Little Sandy River dam under the old bridge at Argillite. The dam was in the original plan of Thayer and Hunnewell back in 1865. No trace of the dam is visible today, as the dam was made of logs and abandoned in the 1920s.

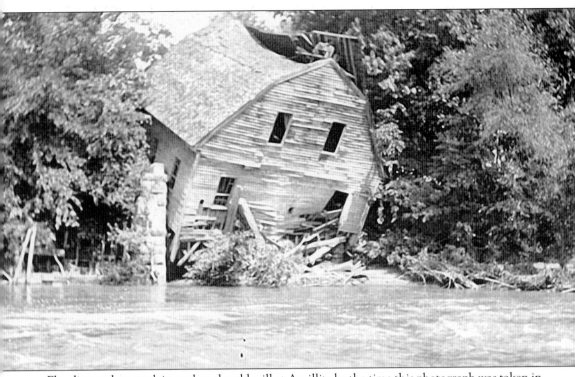

Flooding and age took its tool on the old mill at Argillite by the time this photograph was taken in the late 1930s. The furnace at this location stopped producing iron in 1888. The mill stopped for good in the early 1920s. The foundation stones that held up the mill can still be viewed today.

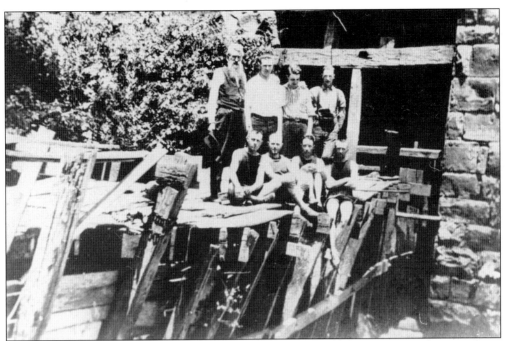

In the late 1920s, the old mill was still standing but had stopped operation several years before. This picture shows several young men ready to swim in the Little Sandy River just below the old mill. The currents were a popular swimming attraction for decades after this image was taken in 1931.

By the late 1960s, the bridge and a mill foundation pillar were all that remained of the Argillite mill. The Eastern Kentucky Railway purchased the mill around 1867 and owned the mill and property until the early 1900s. The bridge pictured was built to accommodate milled goods as well as materials from the Buffalo furnace. The bridge was replaced in 1984.

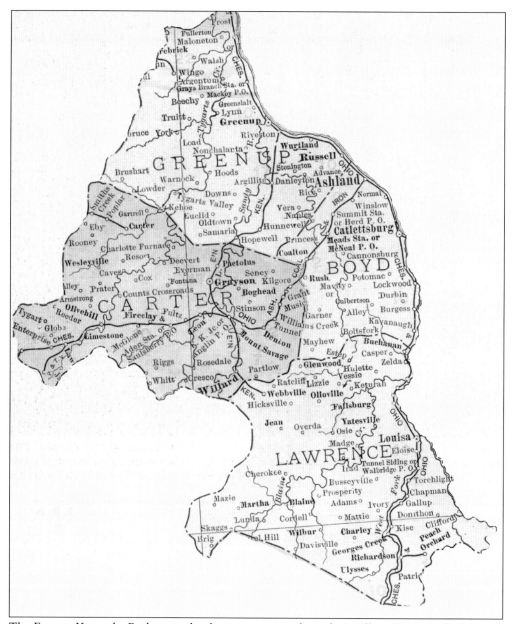

The Eastern Kentucky Railway is clearly seen running through Argillite, Hunnewell, Grayson, and Willard, ending in Webbville on this map from about 1900. A number of towns and villages retain the names they had at this time, while some town names are today unknown. The map also shows railroads, one coming from Ashland going through Denton in Carter County.

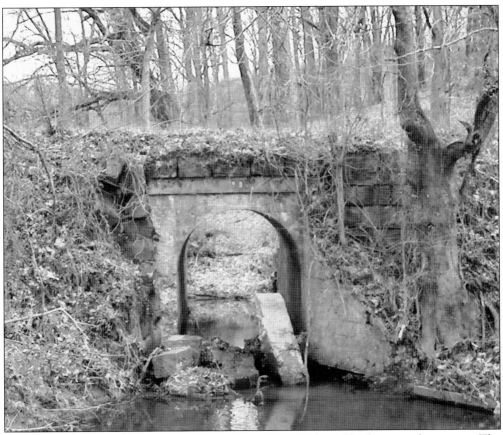

In early 1902, the Eastern Kentucky Railway began a number of bridge upgrade projects. The flood of 1899 had destroyed half a dozen bridges near Riverton. Photographed is one of those upgrades from 1905 as it looks today, with the rail bed running above. This is located a couple of miles up Route 1 from Greenup.

EASTERN KENTUCKY RAILWAY CO.
STURGIS G. BATES, Receiver.

R. R. B.

The Eastern Kentucky Railway had telegraph machines at half a dozen stops along the railway. When a message was received, the note was placed in an envelope like the one pictured here and given to the recipient. The offices of the Eastern Kentucky Railway used printed envelopes to send all official correspondence.

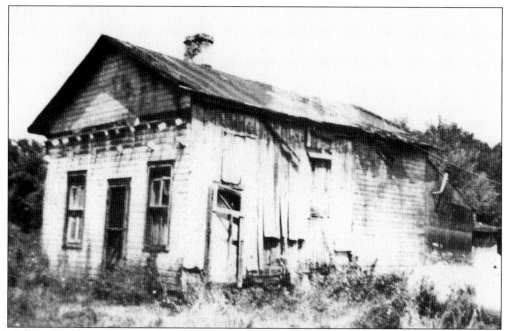

When the northern end of the railway was abandoned in 1926, many of the building that had stood along the railway fell into disrepair. Pictured in the 1960s is the old store at Hunnewell. Several of the older buildings in Hunnewell and throughout the old rail path were moved from near the highway and remodeled.

Pictured is the old Hunnewell store in the late 1960s. In its heyday, the Hunnewell area was considered a choice town in Greenup County. The county seat went to Greenup instead of Hunnewell by the margin of just one vote. Today several Eastern Kentucky Railway buildings remain and are in use.

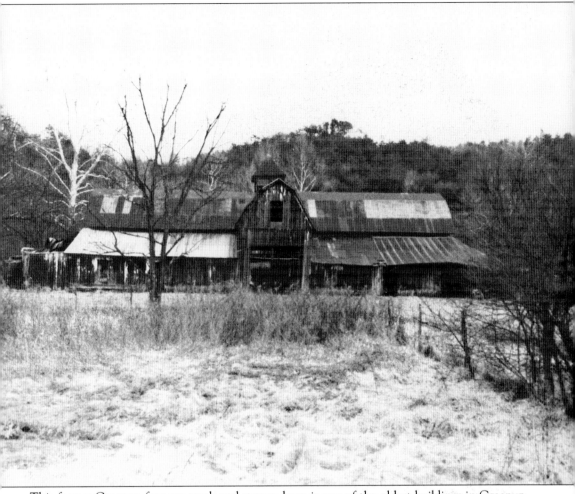

This former Greenup furnace stock and storage barn is one of the oldest buildings in Greenup County. The barn can be traced back to the beginning of the furnace in the early 1860s. The Eastern Kentucky Railway purchased the barn and furnace in 1867, renaming the furnace and town Hunnewell.

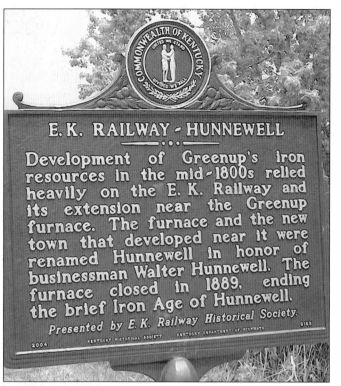

COMMONWEALTH OF KENTUCKY
UNITED WE STAND
DIVIDED WE FALL

E. K. RAILWAY - HUNNEWELL

Development of Greenup's iron resources in the mid-1800s relied heavily on the E. K. Railway and its extension near the Greenup furnace. The furnace and the new town that developed near it were renamed Hunnewell in honor of businessman Walter Hunnewell. The furnace closed in 1889, ending the brief Iron Age of Hunnewell.

Presented by E. K. Railway Historical Society.

2004 KENTUCKY HISTORICAL SOCIETY KENTUCKY DEPARTMENT OF HIGHWAYS 8163

This historical highway marker dedicated to the Eastern Kentucky Railway's Hunnewell stop is located near the old barn and across the street from the old furnace. This was the fourth marker to be dedicated and was done in 2004. The Eastern Kentucky Railway Historical Society is planning on erecting markers in Hitchins and Willard.

Occasionally items from the Eastern Kentucky Railway will surface at railroad shows and gatherings. Locks and keys are highly sought-after items and are considered very valuable. This photograph shows an Eastern Kentucky Railway switch lock and keys. They were used by Fred Duncan and now belong to his daughter Helen.

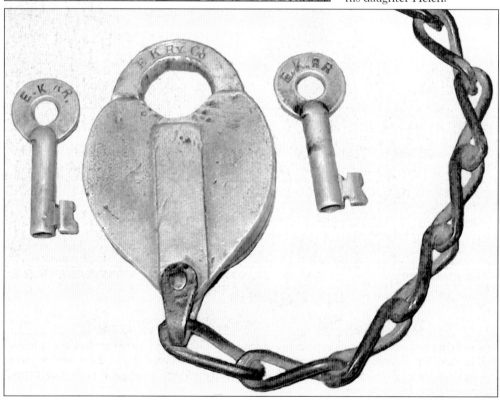

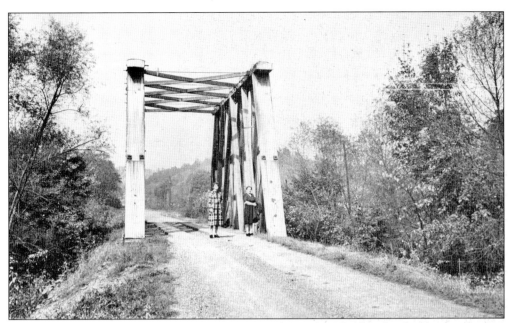

Two young ladies stand near an old Eastern Kentucky Railway bridge that has been redone to accommodate vehicle traffic. Several bridges from the railway survive and are used today. One is located near Hopewell, and two are located south of Grayson, Kentucky. There have been several attempts to demolish the bridges and replace them with larger structures.

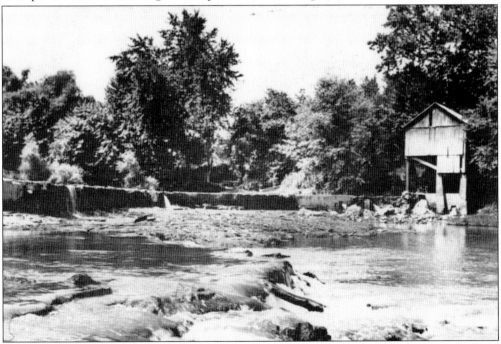

The old dam and mill at Pactolus, pictured in the early 1900s, fared no better than the dam and mill at Argillite. Eventually both were abandoned to the elements. Today there are few traces of the Pactolus mill and bridge. When the railway abandoned its original path, many small businesses went the same way.

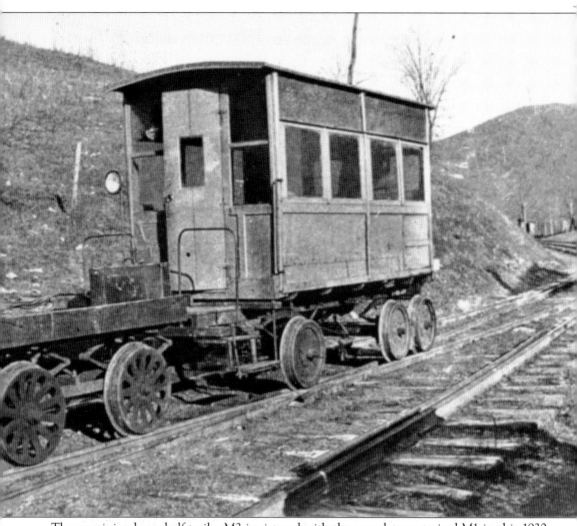

The remaining lower-half trailer M2 is pictured with the complete motorized M1 in this 1930 photograph of the Blue Goose near Willard, Kentucky. About two years later, the Eastern Kentucky Southern Railway dismantled M1 along with the rest of M2 and sold all the metal for scrap in an attempt to recover any amount in return on the $30,000 purchase of the southern route from the Eastern Kentucky Railway. Arrangements were made for an initial down payment of $15,000, and the last payment was due on June 5, 1929; this included the shop and depot in Grayson as well as the depots in Hitchins, Willard, Webbville, and all remaining southern rolling stock. The Eastern Kentucky Southern Railway purchase of the southern portion meant the end of the loud and rickety Blue Goose as well as experimental railcar travel in eastern Kentucky.

This photograph shows the storage shed belonging to the Evans Lumber Company in Grayson. A heavy snow had caused major structural damage to the shed, but upon closer examination, this shed was the old Eastern Kentucky Southern Railway shop. This photograph was taken shortly before the building was destroyed.

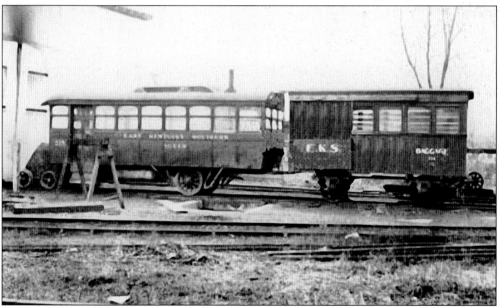

In this photograph from about 1931, Queen and her baggage trailer are parked at the Eastern Kentucky Southern Railway shops in Grayson. Queen was parked here for maintenance on her Ford gasoline engine, and she was also parked here at the end of each working day to await another day along the southern route.

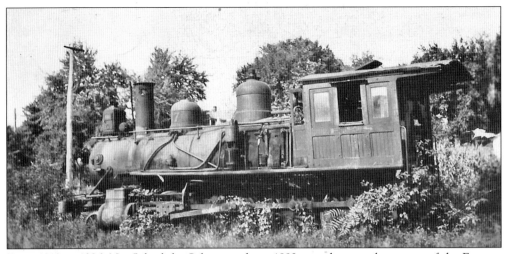

From 1912 to 1926, No. 5, built by Schenectady in 1892, ran the complete route of the Eastern Kentucky Railway. In 1928, No. 5, a Class F-10 4-6-0, was transferred to the newly formed Eastern Kentucky Southern Railway. Note the EKS initials under the open window in this photograph taken several years after abandonment.

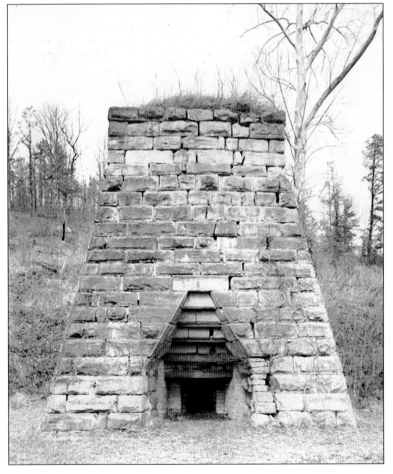

The Mount Savage furnace contributed income for the Eastern Kentucky Railway during the late 1800s. This furnace, along with the Buffalo furnace in Greenup, transferred its iron overland to be shipped via the railway. Both furnaces were major factors with helping the railway earn money. Today this rock-blast furnace is all that remains of the Mount Savage furnace.

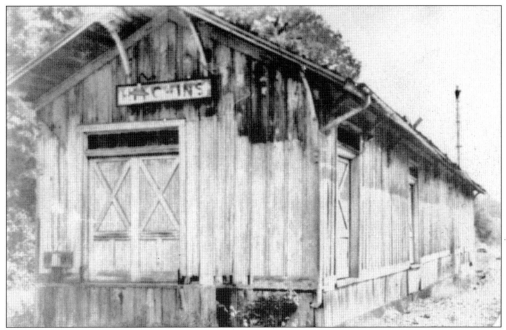

Hitchins experienced the loss of the Eastern Kentucky Railway, the brick company, and the C&O Railroad. The depot went into disrepair in the 1960s and no longer exists today. The Hitchins depot sign is said to be on display at a railroad museum in Maryland. This will be the site of the next Eastern Kentucky Railway historical highway marker.

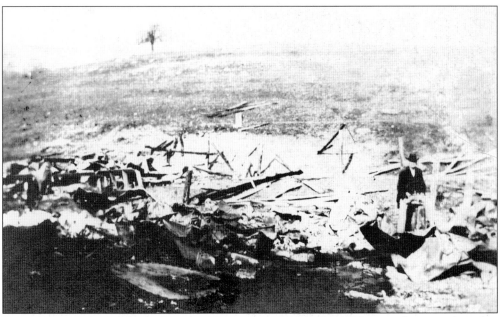

Several Eastern Kentucky Railway buildings were razed in the 1920s to make room for other buildings along the old railway route. This photograph shows the burned remains of a building that once stood near Grayson. Today only a few buildings used by the railway remain, and most of them are located at Hunnewell.

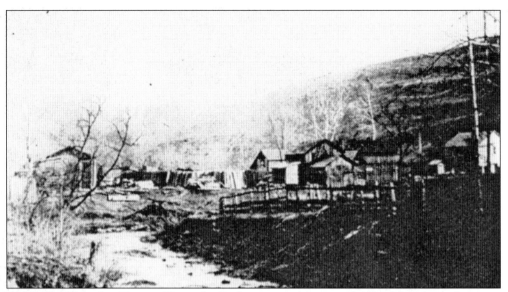

Webbville, like other Eastern Kentucky Railway stops, began to decline after the railway was abandoned in 1933. People moved to find jobs, and businesses moved to find people. The Duncan family moved from Webbville to Augusta, Kentucky, in the 1930s. Shown is a photograph of the Webbville yards just after abandonment.

Pictured in many of the old photographs of the Eastern Kentucky Railway at Webbville is the old store. This store has changed names over time, but the structure of the building has changed very little since the railway days. Today the building is empty and still standing where it has stood through so much in Webbville.

The Eastern Kentucky Railway Historical Society has a collection of railway artifacts that can be viewed. They are located at the McConnell House in Wurtland, Kentucky. More information about this historic home, and information regarding visits can be found at www.ekrailroad.com.

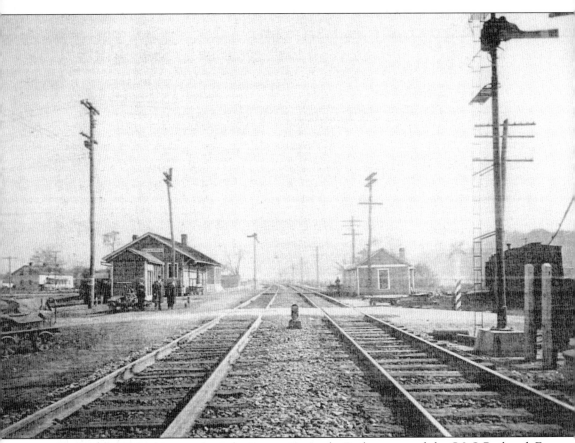

In the mid-1930s, this was where the Eastern Kentucky Railway crossed the C&O Railroad. For several years, Riverton remained a stop for people riding the C&O Railroad between Cincinnati and Huntington, West Virginia. Today Riverton is no longer a city but is considered the eastern part of Greenup, Kentucky.

In February 2007, Keenan Baldridge of Barboursville, West Virginia, did a report and summary on the Eastern Kentucky Railway. He wanted to do something that no one else in his school was going to do, and he wanted to impress his dad. He did just that, taking second place in his division at the social studies fair under the theme "Eastern Kentucky Railway, Unlocking Railroad History."

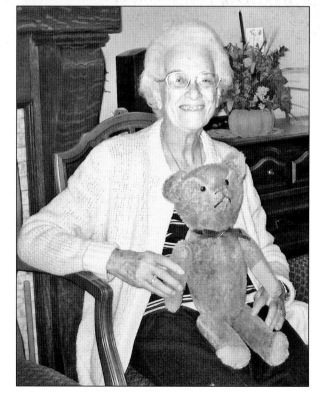

Helen Duncan Dunkle married and moved to Circleville, Ohio, where she and her husband shared their home with her parents, Fred and Belva Green Duncan, until their deaths over 30 years ago. Helen continues to be active in the Eastern Kentucky Railway Historical Society and is a wealth of information regarding the railway. Her teddy bear has been at her side for nearly 80 years.

Across America, People are Discovering Something Wonderful. Their Heritage.

Arcadia Publishing is the leading local history publisher in the United States. With more than 3,000 titles in print and hundreds of new titles released every year, Arcadia has extensive specialized experience chronicling the history of communities and celebrating America's hidden stories, bringing to life the people, places, and events from the past. To discover the history of other communities across the nation, please visit:

www.arcadiapublishing.com

Customized search tools allow you to find regional history books about the town where you grew up, the cities where your friends and family live, the town where your parents met, or even that retirement spot you've been dreaming about.